EVANSTON PUBLIC LIBRARY

5786
D1312181

743.87 Pavel.J
Pavelec, Jim.
Hell beasts :

HELL BEASTS

How to Draw Grotesque Fantasy Creatures

JIM PAVELEC

IMPACT
CINCINNATI, OHIO
www.impact-books.com

EVANSTON PUBLIC LIBRARY
1703 ORRINGTON AVENUE
EVANSTON, ILLINOIS 60201

NOV 2 6 2007

Hell Beasts: How to Draw Grotesque Fantasy Creatures.
Copyright © 2007 by Jim Pavelec. Manufactured in China. All rights reserved. No part of this book may be reproduced in any form or by any electronic or mechanical means including information storage and retrieval systems without permission in writing from the publisher, except by a reviewer who may quote brief passages in a review. Published by North Light Books, an imprint of F+W Publications, Inc., 4700 East Galbraith Road, Cincinnati, Ohio, 45236. (800) 289-0963. First Edition.

Other fine North Light Books are available from your local bookstore, art supply store or direct from the publisher.

11 10 09 08 07 5 4 3 2 1

DISTRIBUTED IN CANADA BY FRASER DIRECT
100 Armstrong Avenue
Georgetown, ON, Canada L7G 5S4
Tel: (905) 877-4411

DISTRIBUTED IN THE U.K. AND EUROPE BY DAVID & CHARLES
Brunel House, Newton Abbot, Devon, TQ12 4PU, England
Tel: (+44) 1626 323200, Fax: (+44) 1626 323319
Email: postmaster@davidandcharles.co.uk

DISTRIBUTED IN AUSTRALIA BY CAPRICORN LINK
P.O. Box 704, S. Windsor NSW, 2756 Australia
Tel: (02) 4577-3555

Library of Congress Cataloging in Publication Data
Pavelec, Jim.
 Hell beasts : how to draw grotesque fantasy creatures / by Jim Pavelec.
 p. cm.
 Includes index.
 ISBN-13: 978-1-58180-926-8 (pbk. : alk. paper)
 ISBN-10: 1-58180-926-3 (pbk. : alk. paper)
 1. Monsters in art . 2. Animals, Mythical, in art. 3. Drawing--Technique. I. Title.
 NC825.M6P38 2007
 743'. 8--dc22 2006103124

Edited by Layne Vanover and Jeffrey Blocksidge
Designed by Guy Kelly
Production coordinated by Matt Wagner

fw
F+W PUBLICATIONS, INC.

metric conversion chart

To convert	to	multiply by
Inches	Centimeters	2.54
Centimeters	Inches	0.4
Feet	Centimeters	30.5
Centimeters	Feet	0.03
Yards	Meters	0.9
Meters	Yards	1.1

ABOUT THE AUTHOR

In 1974, after viewing *The Exorcist* at the tender age of two, a pattern began in young Jim Pavelec's life, one that he cultivates to this very day. That pattern, my friends, is an ever-increasing love of imagery most foul. As a child, demons and monsters and devils of all sorts consumed his every waking hour and serenaded him through the night. But what would be the best way for this neophyte to express his love? The options were many. His eventual choice: paper and pencil, and a little paint, too.

Armed with his visual encyclopedia of artists past, a firm hatred of humanity, and the desire to dominate, Jim set off into the gaming world where he slaved tirelessly for companies such as Wizards of the Coast on their *Magic: the Gathering* and *Dungeons & Dragons* lines, and Upper Deck Entertainment on their *World of Warcraft* game. Jim has also done work for periodicals such as *Heavy Metal* and *Dragon Magazine*.

At the present time, Jim lives a comfortable life with his girlfriend, Aimee, in a house full of that imagery most foul, which makes him happiest of all.

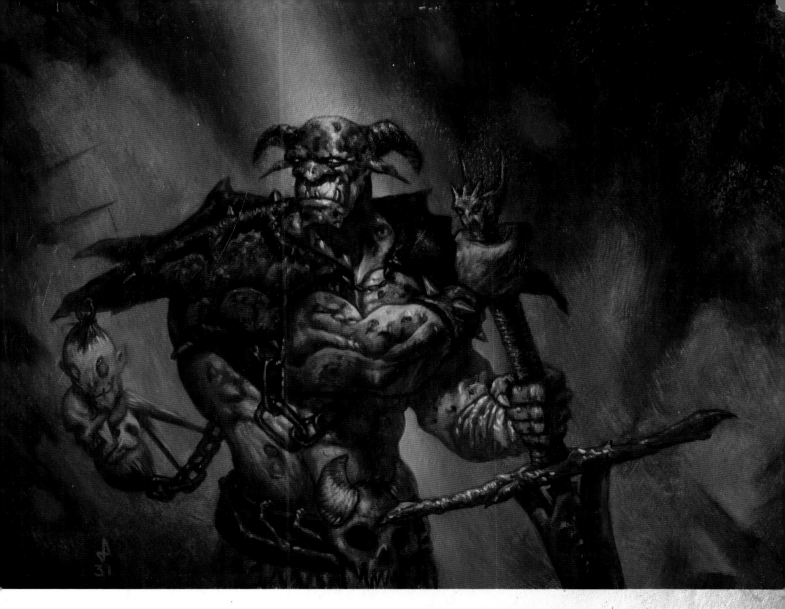

Acknowledgments

A debt of gratitude, payment of which comes through the making of the unholy, is due to Kurt, Mark, and Thomas for their undying devotion to all things evil, vile, and loathsome. Their pure disgust with humanity is a bottomless well from which I draw constant motivation. I also observe my obedience to all creators of darkness. Whether their craft stimulates the visual or the auditory, my senses have forever reveled in their sin, and it's been joyous.

I would like to thank Thomas, Prof, Michael P., Jeremy J., and Jim P. for personally helping me to create better artwork in one fashion or another. I would also like to thank all the people at Impact Books for giving me the opportunity to do this book and the creative freedom that every artist dreams of. Thanks to Donato, Brom, and E.E. Knight for their written contributions to this book. Finally, and most importantly, thank you to Aimee for being the perfect human being.

Dedication

This book is dedicated to Keith Parkinson. An artist of tremendous skill and knowledge is a rare and unique thing, but an artist who is willing to share those attributes with novice artists is practically an anomaly. Keith was a polished gem in a landscape often tarnished by soot and smoke. He was one of my earliest influences and continued to influence me throughout his career, a career that was tragically cut short. I know that I, along with all of my colleagues in the fantasy art world, will continue to turn to his work for inspiration, and remember him fondly.

TABLE OF CONTENTS

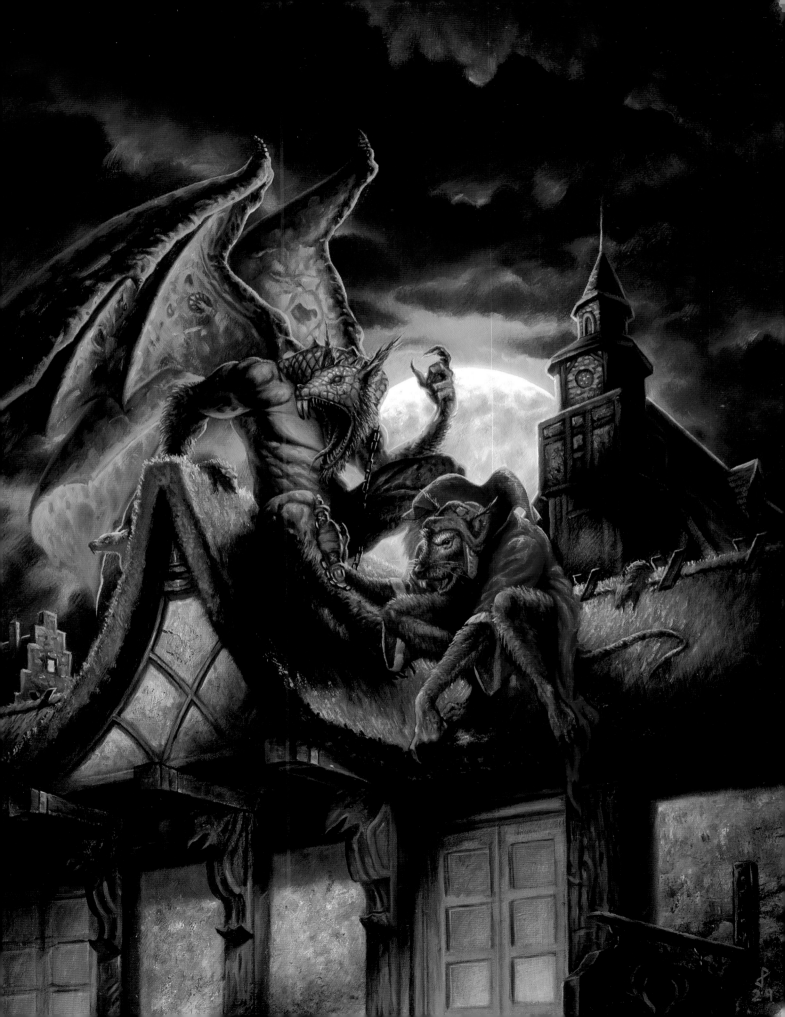

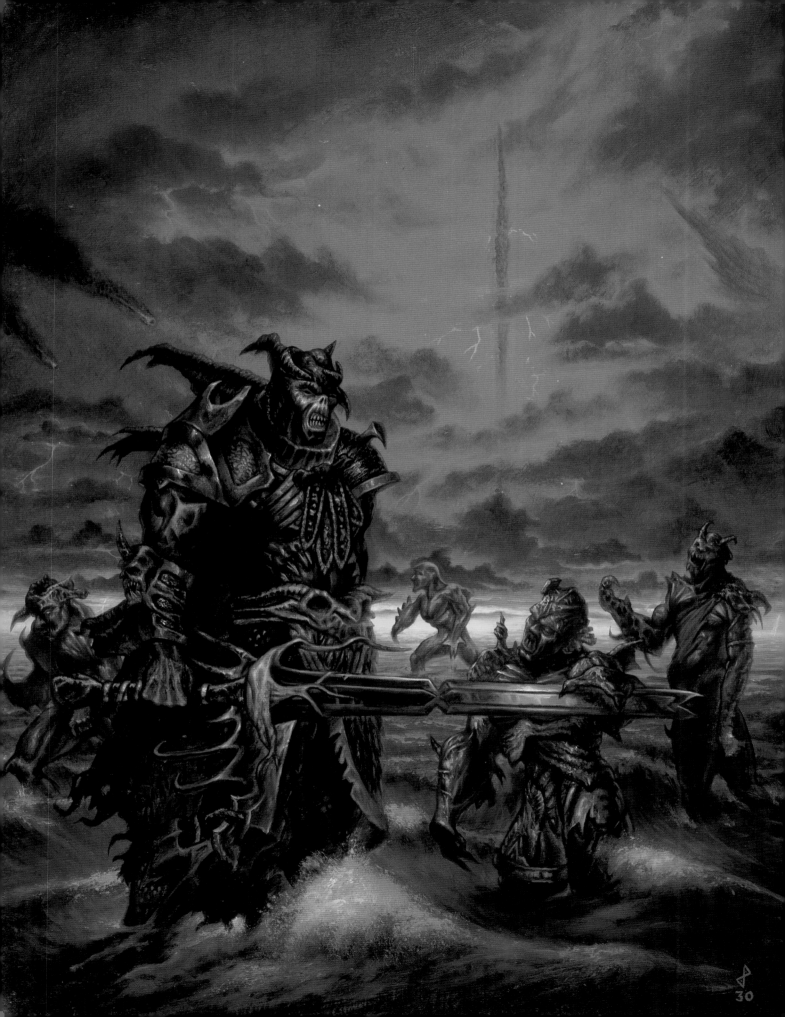

INTRODUCTION

COURTESY OF E.E. KNIGHT, AUTHOR OF THE
VAMPIRE EARTH AND THE *AGE OF FIRE* SERIES:

Remember watching scary movies when you were a little kid? How even if it scared you—especially if it scared you—you had to look at the monster? I did it using my fingers as shutters.

Monsters draw attention. They demand it, often at the expense of the heroes who slay them. While I couldn't tell you what Jason looked like in Ray Harryhausen's *Jason and the Argonauts*, like most viewers I remember the bronze titan Talos, the harpies, the hydra, and of course the skeleton warriors in remarkable detail.

We watch monsters with the same dreadful fascination that makes us look at car accidents. A well-realized creature will stalk us in our dreams for years to come. Personal experience tells me that a good piece of art will cause a reader to pick up a novel and look inside. Nothing makes me pick up a book faster than a great monster on the cover.

Jim Pavelec is a master creator of monsters. Whether he works in the cool hues of a misty nightmare or the hot primary splatter of an abattoir, the realism in his depiction convinces. I get the feeling when looking at his work that the subjects have lives and intentions of their own. Jim is just observing and recording like a diligent *National Geographic* photographer.

What dark, psychic, ecosphere breeds these beasts? Jim is a big, humorous man who is good to his friends and kind to strangers. While he approaches his work with patient intensity, I can assure you he doesn't have staring Rasputin eyes or pointed ears. I suspect he draws inspiration from that same dark well I sometimes use—the shadowy place within our subconscious where the monsters of our ids lurk, begging us to look at the car accident or to become quiet and attentive at the morgue. You've got one too, even if you haven't been raised on a diet of creature features. Go take a look at what's down there. If not now, maybe next time you turn out the lights and fall asleep.

Now you've got your inspiration. But how do you bring it to life? Let's read on and find out ...

What You'll Need to Get Started

Dr. Victor Frankenstein needed a uniquely appointed laboratory, a comprehensive knowledge of many medical disciplines and, of course, body parts from human corpses to create his monster. You, on the other hand, will not need quite so much. In fact, you can begin creating your own monsters with very little. A couple of cheap pencils and erasers and a few sheets of ordinary paper may be all you require to bring your monster to life.

Drawing Tools

There are a great many drawing tools, enough to fill this entire book, so I will narrow the scope to some of the more common tools artists use to create black and white and gray scale drawings.

Wood-Cased Pencils. The traditional standard for drawing and a great all-around utensil. The graphite in these comes in a range of densities. The Bs are the softer graphites. The greater the number that corresponds with the B, the softer the graphite. Conversely, the Hs are harder graphites. The same numbering system applies.

Mechanical Pencils. Mechanical pencils contain a compartment that can hold a large quantity of uniformly sized graphite sticks (called leads, even though they are not made of lead). A common size is .5mm. A mechanism built into the pencil allows you to advance the lead until it reaches the desired length. The great thing about mechanical pencils is that they do not get ground down into nubs like ordinary pencils, and they do not require sharpening. They are great for detail work, but do not allow for the broad strokes the wood-cased pencil gives you.

Lead Holder. This tool, often used by architects, holds a single long piece of 2mm graphite. When used in conjunction with its specifically designed sharpener, a very long and sharp point can be produced. It is ideal for fine detailing.

Charcoal. Charcoal is the carbon residue from burnt wood and other materials. Unlike graphite, charcoal is porous, making it both messier to use and prone to smudging. It is this malleability, though, that makes it an invaluable tool when trying to create a fluid gesture or interesting shape for a creature design. It comes wood cased or in a raw form called vine charcoal.

Ink. Many artists like to use ink from the beginning stages of a drawing all the way to the finished product. Technical pens, markers, and even ballpoint pens are ideal for capturing gesture and rhythm lines because of their natural fluidity. They are also great for roughing out ideas early on. Let your pen move around freely and build up areas until you get some interesting shapes and elements to work with. Artists more skilled with ink than myself are able to create lavish finished renderings with a combination of the different ink tools shown here.

Which tools you find most valuable will be up to you to discover. The most important thing is that you experiment. Even at this stage of my career I try out new tools and media to give my work a jolt. It is to your advantage to try all of these tools, either by themselves or in conjunction with each other, in order to become the best artist you can.

Correcting Tools

It's time-consuming to have to switch out a limb like old Doc Frankenstein. Luckily for you, all you need to do is erase the appendage and start over.

Kneaded Eraser. This malleable eraser can be your best friend. Since it is big, it can be used to clean up large areas but it can also be shaped into a point in order to get into tight areas.

Plastic Erasers. You can get these in blocks for large areas, or in a form much like a mechanical pencil that clicks out eraser instead of lead.

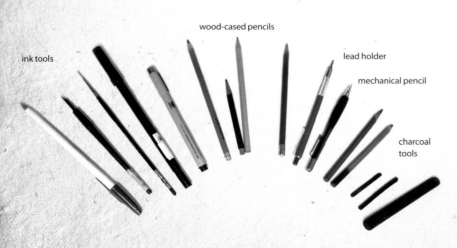

ink tools

wood-cased pencils

lead holder

mechanical pencil

charcoal tools

Gum Eraser. These are good for erasing large areas but can be a bit messy to use.

Large Bristle Brush. After erasing, little bits of eraser will be left behind on your paper. Use this tool instead of your hands to brush them off the page. Your hands contain oils which will smear the graphite and potentially ruin detailed areas that you have spent much time and effort rendering.

One final word on erasers: Be wary of very hard erasers, as they can cause damage to the surface of your paper.

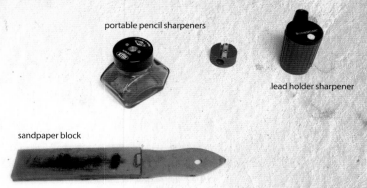

portable pencil sharpeners

lead holder sharpener

sandpaper block

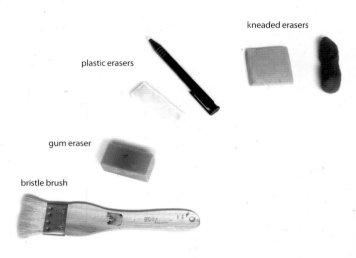

kneaded erasers

plastic erasers

gum eraser

bristle brush

SHARPENING TOOLS

Dr. Frankenstein wouldn't try to open a skull case with a dull bone saw. Likewise you shouldn't try drawing with dull tools.

Portable Pencil Sharpeners. These work for all wood-cased drawing tools. Just put the pencil in and spin it until you get the point you want. Try out several of these before you make a purchase, as their quality can vary greatly.

Lead Holder Sharpener. This sharpener works only with the lead holder mentioned in the Drawing Tools section. Place the lead holder in the opening and rotate the freely moving top of the sharpener while holding the base of the sharpener firmly in place. This will give you one of the best points you can achieve on a drawing tool.

Sandpaper Block. This type of sharpener is made up of a stack of individual sheets of sandpaper secured to a wooden handle. It works especially well for charcoal pencils and other wood-cased pencils. Grab the wooden handle and place the tip of your pencil on the sandpaper at an angle that will give you the point you desire. Move the

pencil back and forth quickly while spinning it to get a nice point. Once a piece of sandpaper becomes clogged with residue, just tear it off and a fresh one takes its place.

PAPERS

Another entire book could be devoted to the numerous papers and supports available to you. There is nothing wrong with working on something as inexpensive and easy to find as regular printer paper when first trying your hand at drawing. If you decide to move up to sketchbooks and art papers designed specifically for drawing, you will have some decisions to make. First, decide how much money you want to spend. High-end art papers can be incredibly expensive. Also, you have to decide if you prefer working on a very smooth surface or something with a little tooth to it. Keep in mind when looking at papers that the term *Hot-Pressed* means the paper has a smoother texture, while the term *Cold-Pressed* indicates a rougher surface. Also, papers have a pound number assigned to them. The greater the number, the thicker and sturdier the paper will be. I usually do finished work on papers between 80 and 140 lbs.

Pictured here are a variety of papers and sketchbooks I have used.

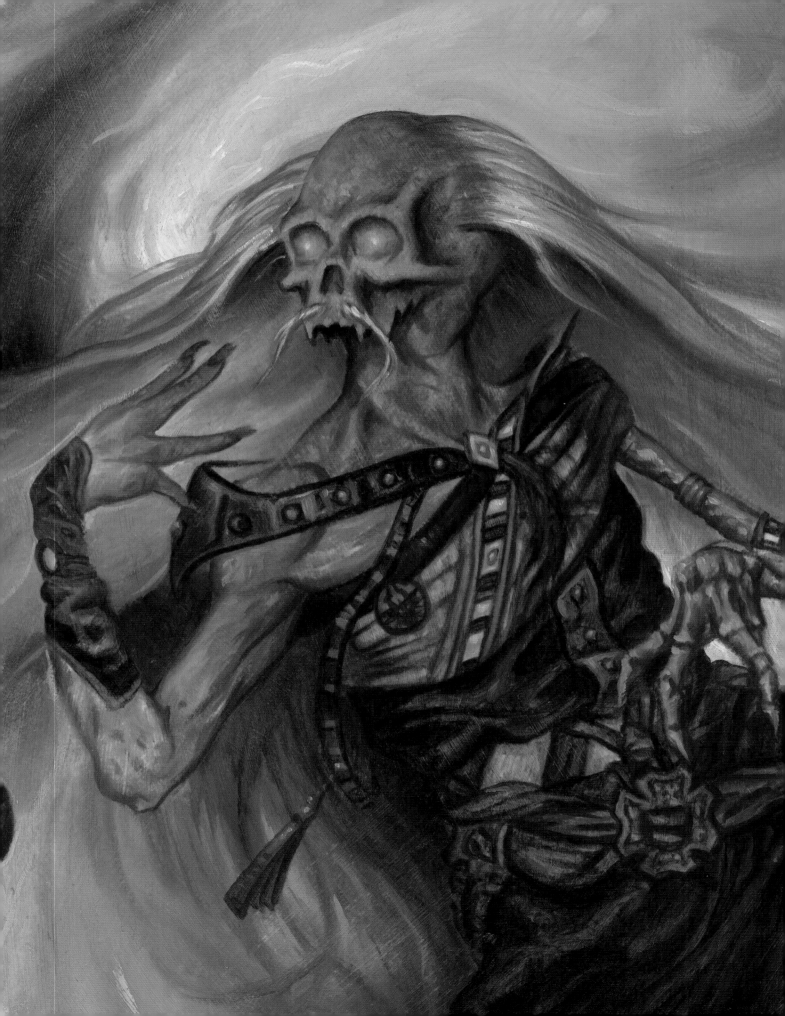

DRAWING BASICS

O ver the past ten years, the world of fantasy art has come to rely more and more on output generated by computer programs. Artists pull figures from photos and precon-figured 3-D models and drop them into fantasy backgrounds. While some of this imagery may look pretty cool, such artists are limited in their capabilities if they don't have a firm under-standing of basic drawing, painting, and sculpting concepts. The best artists in the business, whether they work traditionally or digitally, have a vast body of knowledge in the fundamentals of drawing. The following chapter aims to provide you with a solid foundation of these fundamen-tals, showing you how principles such as shape, gesture, and texture will help you become a better artist, and ultimately, a better monster maker.

BASIC SHAPES

Everything you see—and for the purposes of this book, everything you imagine—can be simplified into basic geometric shapes. Each of the drawings you will complete in the demonstration chapters that follow begin as nothing more than a series of primitive lines and shapes. When dealing with shape in your designs, always start out simply, implementing basic shapes early in the process and adding more complexity and detail to these shapes as you develop your drawing. You should also keep in mind that the overall shape chosen for a particular piece will have a lasting impact on the finished design. As such, successfully learning to choose the right combination of basic shapes for your compositions is an imperative part of the creative process.

BASIC SHAPES
The most common basic shapes are the square, circle, rectangle, and triangle. These are often all you need to create a strong foundation for good design. Lay these shapes on top of one another in a variety of ways to see how many complex objects you can come up with.

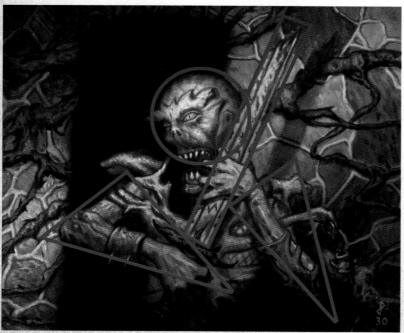

EXAMINING THE FOUNDATION OF DESIGN
Observe the bold blue lines placed on top of this finished composition. Although it seems like a very intricate design, the basic shape overlays show you how simple it really is, illustrating that even the most complex-looking creation can be broken down into simplified shapes.

POLYGONS

In addition to the four basic shapes discussed on the previous page, your compositions will also contain slightly more complex shapes known as polygons. A polygon is any shape with three or more sides. Each of a polygon's sides can vary in length and connect at numerous different angles. Although the square, rectangle, and triangle are technically polygons (as they each have three or more sides), they are far more basic than most other polygons. This is because these three shapes will always have sides of equal length and angles of equal measure.

Four polygons in particular, all four-sided, will be very useful in composing the creatures in this book: the quadrilateral, parallelogram, rhombus, and trapezoid. Experiment with these shapes, arranging them on top of each other in various configurations to see what types of recognizable figures you can create.

QUADRILATERAL
A shape with four sides, none of which are parallel, is generically called a quadrilateral.

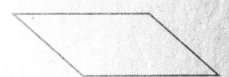
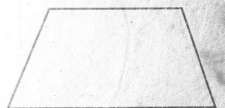

PARALLELOGRAM
This four-sided shape has two opposing sides of equal length that run parallel to each other, making the opposing angles identical.

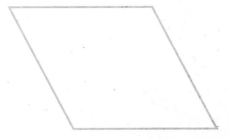

RHOMBUS
Like the square, a rhombus has four sides of equal length; however, because two of the sides are slanted, there are no 90-degree angles.

TRAPEZOID
A trapezoid has one pair of sides that are parallel but which differ in length.

EXAMINING THE FOUNDATION OF DESIGN
Once again look closely at the blue lines placed on top of a completed painting. Notice how many polygons were used to lay in the basic design of this monster.

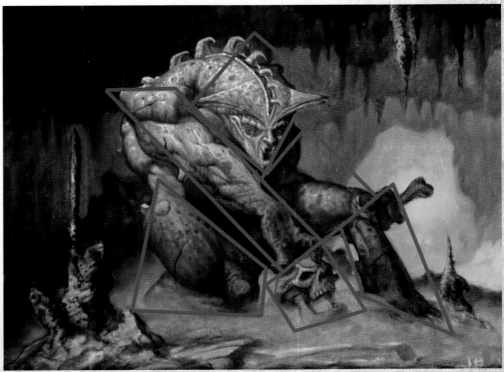

Gesture

Gesture, or the overall movement and pose of a figure, is the foundation of any good composition, giving your drawings the fluidity and force necessary to capture the viewer's eye. You can set the mood for an entire piece by first laying out a simple gesture drawing consisting of only a few lines. Likewise, implementing sweeping and bold gesture lines can create drama and visual impact, adding spice to an otherwise ordinary design.

There are two types of gesture lines: *primary* and *secondary*. The primary gesture line is the fluid mark that runs along the figure's centerline. For example, when looking at a humanoid figure from the front, the primary gesture line goes from the head, through the center of the abdomen, then to the pelvis, where if shifts into either the action leg or the weight-bearing leg.

Secondary gesture lines, or rhythm lines, are lines that flow through the form connecting secondary body parts such as limbs, tails, wings, and tentacles. Secondary gesture lines can move from one side of a form to the other or between elements on the same side.

Identifying Gesture Lines
For reference purposes throughout the book, primary gesture lines are indicated by a bold red line, and secondary gesture lines are suggested by green lines. The following examples illustrate both primary and secondary gesture lines.

14

POSES

The kind of pose you decide to use for your creation will depend heavily on what kind of mood you want to set for each piece. For the sake of simplicity, there are two basic types of poses your creatures can assume: *action* or *iconic*.

Action poses are integral to monster drawing. Monsters charge, leap, fly, swing heavy weapons, contort in rage, and perpetrate all manners of unspeakable violence. To capture these actions, start with a strong gesture drawing, making your lines curve and sweep. Don't limit yourself, but work with a quick and loose movement of your drawing tool. If a pose isn't working for you, move onto another one right away. The more you labor over an action gesture, the stiffer it becomes.

The iconic pose, although more still by nature than the action pose, is just as powerful and compelling. It is stoic in nature—a creature standing exhausted over his slain victims, a demon lord perched upon his twisted throne, a goblin hunched ready to strike—suggesting power at rest. The iconic pose tends to be more shape-oriented overall, so rely on your secondary gesture lines to create movement within the figure and to pull the viewer's eye deeper into the pose.

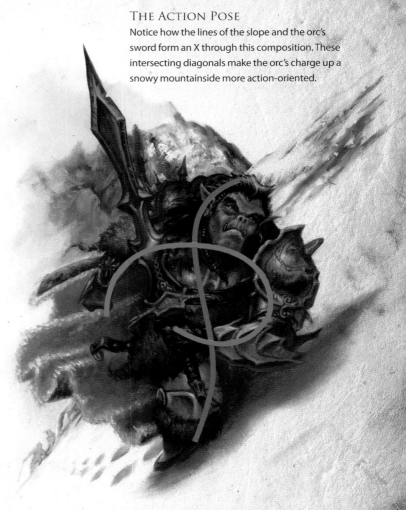

THE ACTION POSE
Notice how the lines of the slope and the orc's sword form an X through this composition. These intersecting diagonals make the orc's charge up a snowy mountainside more action-oriented.

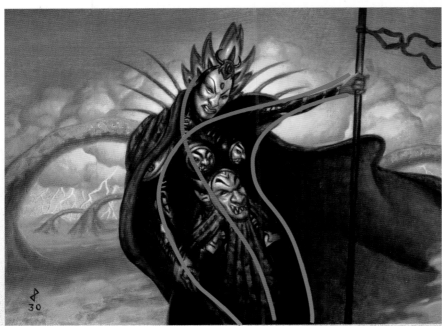

THE ICONIC POSE
An Iconic pose doesn't have to be boring. Although this shadowy female warrior is standing still, the movement of her gesture and her flowing cape make for a dramatic composition.

LIGHT AND SHADOW

An artist creates the illusion of three dimensions on a two-dimensional surface by rendering light and shadow. Through accurate use of light and shadow, the basic two-dimensional shapes of the square, circle, rectangle, and triangle become a cube, sphere, cylinder, and cone.

For instance, take a circle and pretend that a light source has been placed above and to the right of it. The area where the light lands directly on the object and is at its brightest is called the *highlight*. As you move across the sphere, its curvature begins to obscure the light and creates what is known as the form shadow. The core of the *form shadow* is the darkest area on the object. Also, since the sphere is sitting on a surface, it throws an oblong shadow across that surface called a *cast shadow*. The cast shadow starts out with a dark, hard edge and softens as it moves away from the object casting it. Finally, on the shadowed side of the sphere, a small amount of light bounces back onto the form from the surrounding surface. This is called *reflected light*.

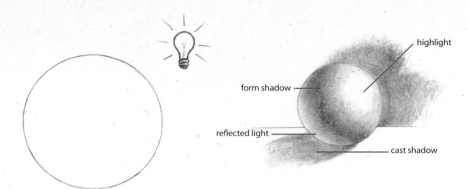

CREATING THREE DIMENSIONS
By placing a light source above and to the right of a basic circle and adding the proper shadows and highlights, we are able to create a sphere.

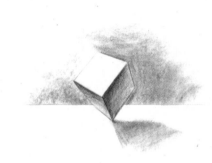

PRACTICING VARIOUS LIGHTING ARRANGEMENTS
Here are examples of other common lighting setups you'll encounter when drawing: a square lit from the upper left (cube); a rectangle lit from above (cylinder); and a triangle lit from behind (cone).

shading techniques for creating shadows

BLENDING WITH CHARCOAL
Draw shadows with charcoal, blending with your finger and picking out lighter areas with your kneaded eraser.

PENCIL HATCHING
Lay short parallel pencil strokes next to each other. The closer together they are, the darker the tone.

PENCIL CROSSHATCHING
Begin as you did with hatching, but lay a second set of marks over the first, moving in a different angle.

LIGHT, SHADOW AND MONSTERS

Monsters are born out of shadow. Therefore, it is of the utmost importance that you master the use of light and shadow in order to create truly frightening fiends. Let's look at some finished monster pieces to see to what effect the basics of light and shadow were applied. It is also a good idea to use light and shadow to your advantage to create mood. A creature can be made much creepier by focusing light in certain areas and letting the rest fall into shadow.

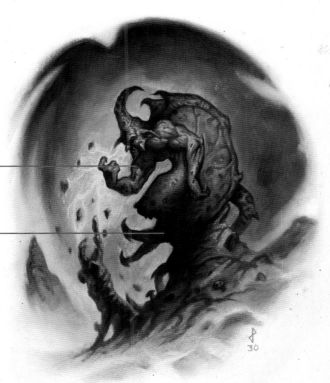

Notice the hard edge of the cast shadow on his bicep.

This shadowed area creates a silhouette that gives the creature a strong foundation and creates interesting positive and negative shapes.

LIGHTING TO CREATE EMPHASIS
In this gargoyle illustration, I used several simple lighting tricks to make the piece read easily while maintaining strong visual impact. To begin, I allowed the area from his thigh down to fall into total darkness and become a simple shape. This works well against the light background and allows the viewer's eye to concentrate on the more important detailed areas. I put the most light and the highest level of detail on his head and shoulder, because this is the focal area. Also, I cast a shadow from his head onto his right arm. This pushes that arm back spatially.

LIGHTING TO CREATE MOOD
For this Japanese zombie, I used a very simple lighting effect to make the setting more foreboding. A strong diagonal shadow, which runs just askew of the zombie's main gesture line, is cast across the entire scene. This pulls the viewer's attention directly to the jaundiced and bloodshot eye of the zombie. Even though the light source is bright, almost sunny, the overall feeling is one of rot, decay, and terror.

TEXTURES

An impenetrable hide, a putrefied decaying wound, a furry bone-crushing paw—to draw all of these things convincingly, you need to incorporate a variety of textures into your work. *Texture* is the characteristic appearance of a surface. If you do not employ a diverse range of textures to your monsters, they will end up looking like lifeless plastic models. In this section, we will examine the characteristics of some of the textures that occur on a regular basis throughout this book.

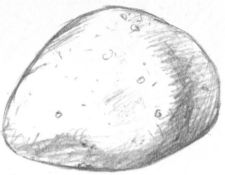

STONE
To create a simple, semismooth pebbly surface, use some crosshatching to define the form, then add randomly placed small ovals and scratchy lines to indicate grooves in the surface.

ELEPHANT/WALRUS HIDE
Elephant and walrus hides are very similar, and are great for drawing hulking monstrosities. The key to this type of skin is that it is very coarse and littered with crags, wrinkles, lumps, and scratches. As with all textures, render the crags and lumps randomly. Overall uniformity leads to a texture that is boring, and worse, distracting, to look at.

TREE BARK
Tree bark, much like elephant hide, has a rough, bumpy, and irregular texture. Move your pencil around quickly and erratically.

WOOD GRAIN
Draw a series of mildly wavy lines that run in a similar direction. Break them up occasionally with concentric ovals to represent knots in the wood.

FUR
Drawing fur is not as difficult as it might seem if you keep one simple rule in mind: Don't draw every single hair. Doing so detracts from the overall image. Keep your strokes short and sketchy. Let your hand go in a variety of directions, as a monster's hair is rarely well kempt, and put the greatest concentration of strokes where the form lies in shadow.

REPTILE SKIN
Reptile skin can be tricky to capture. Since scales are fairly regular in design, it is important to break up the monotony by obscuring them with light or by adding small details like stripes or spots on top of the select scales.

SMOOTH PATTERNED SKIN
Many insects and underwater beasts have a smooth, patterned skin. This is fairly easy to reproduce. Simply draw the pattern as it would appear on the creature. Then, using what you've learned about light and shadow, shape the form to your needs. Use your eraser to bring out the highlights, and cover the pattern with your choice of marks where it falls into shadow.

FEATHERS
Feathers are much like fur in that you should not draw every barb on each feather. Rather, concentrate on the shape of the feather. Indicate the grain of feathers with parallel hatch marks in highly rendered areas.

POINT OF VIEW

An in-depth understanding of point of view, or camera angle as some artists refer to it, is imperative for any good monster maker. *Point of view* refers to the point where the viewer's eye is in relation to the subject matter on the picture plane. Without varied points of view, your work will soon become redundant. When considering a subject, keep three different points of view in mind: *eye level*, *bird's eye*, and *worm's eye*.

EYE LEVEL

In eye level point of view, the viewer is even with the subject, sharing the same ground plane and oftentimes standing eye to eye. This point of view can be used to great effect in poses where you want to create an intense or intimate relationship between your creature and the viewer.

Eye level point of view makes for an interesting juxtaposition in this painting, as the zombie is placed in the framework of a traditional historical portrait.

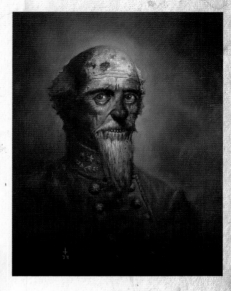

WORM'S EYE VIEW

At worm's eye view the viewer's eye is near the feet of the creature or lower (e.g., if the beast is flying or crouched in a tree high above). This point of view is great for making your beast an imposing force. It also creates a distance between the viewer and your creation, making the viewer feel insignificant in the presence of the beast.

In this piece, positioning the viewer's eye near the creature's knees makes the viewer feel tiny in comparison.

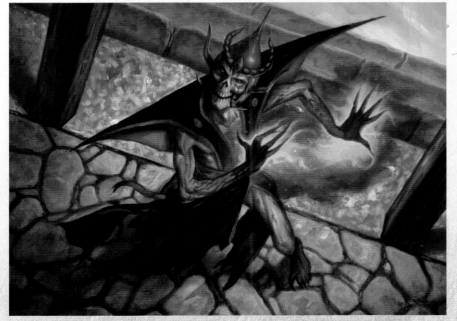

BIRD'S EYE VIEW

When the viewer's vantage point is above the monster, it is called bird's eye point of view. This is ideal for giving your work an otherworldly feel, making the viewer feel like a spectator to an exciting event or to magnificent landscapes below.

In this painting, bird's eye point of view creates a setting that suggests infinite vastness. While looking down on this undead fiend, the viewer sees a huge expanse of amber clouds. If the clouds are beneath the creature's foot plane, then he must be atop some ancient temple that's so tall it penetrates the clouds.

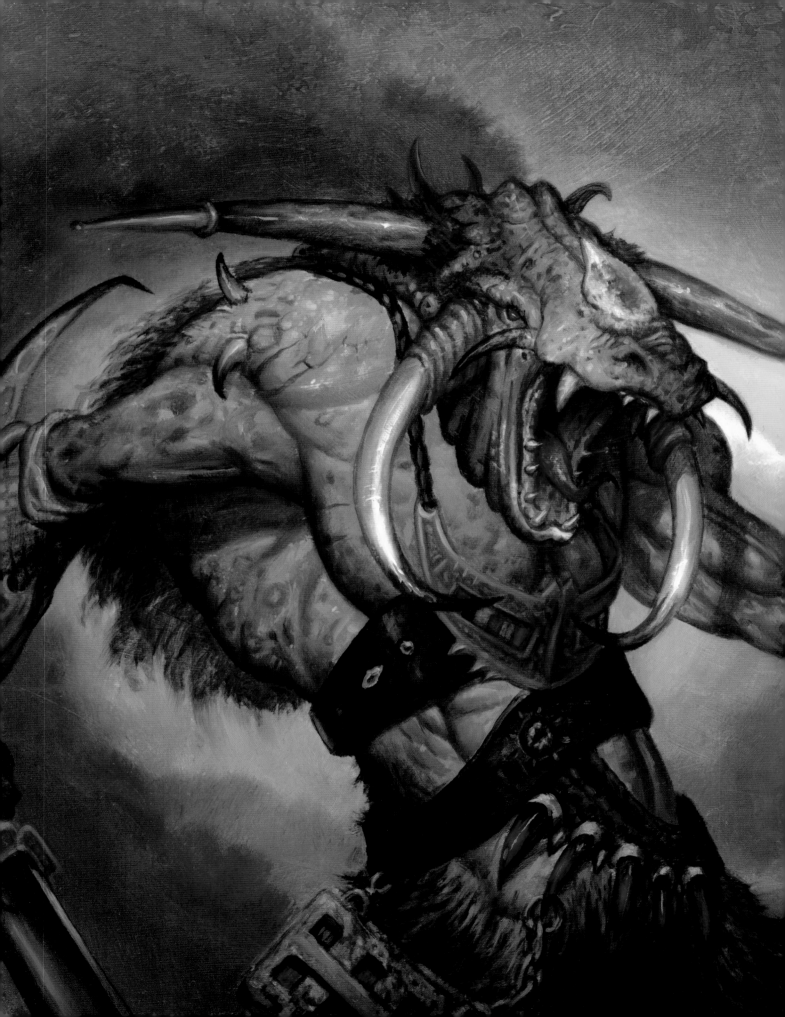

HUMANOID MONSTERS

Humanoid monsters are those that move about by means of bipedal locomotion. Simply put, they walk upright on two legs. From the zombie clawing at the screen of your bedroom window, to the goat-hooved demon thirsting for your immortal soul, humanoid monsters inspire fear like few other beings. Part of the reason is due to their similarity to humans. Most humanoid creations were at one time human, and through death, or forces even more sinister, were transformed into their present state. The glimmer of humanity still remains in their sallow eyes, leaving us to believe that perhaps there is some of them inside of us just waiting to be unleashed.

The Orc

One of the most vile creatures in the arena of fantasy, the orc is sadistic, brutal, and murderous. The most important things to the orcs, other than their constant desires to war and feast on flesh, are their weapons and armor. These give them status among their barbarous cohorts.

 the face of war

In order to focus on the orc's war cry and armor, draw only a partial figure from the knees up at a bird's eye view. The idea is to capture the moment before battle, with the orc dragging a blood-soaked hand across his face in ritualistic bliss.

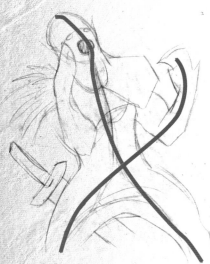

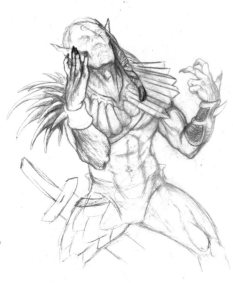

1 Sketch in the basic outline of the orc, paying particular attention to his stance. Tilt his head toward the sky and raise his arms in front of his body to suggest he is in the midst of battle cry. Lightly indicate his armor and sword.

2 Lay in the armor and ornamentation more specifically and shape them to the underlying body parts. Orc armor should be a hodgepodge of motifs and materials. There are no limits. You can use overlapping layers of steel, dragon scales, padded leather, blood-caked fur or feathers, sharp iron spines, studded leather straps, or whatever else you can summon forth with your imagination.

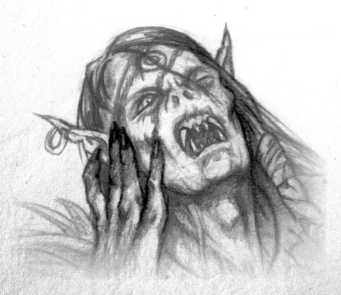

3 Add detail to the orc's face and hand, drawing his mouth wide open to expose sharp fangs and placing shadows and highlights to create an expression that lies between rage and bliss. One of his eyes stares blankly into the sky, the other closes for the internal visualization of the slaughter to come.

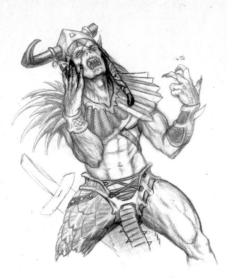

4 Draw the orc's armor in an asymmetrical fashion. Asymmetry suggests chaos, and chaos is what the orc is all about. Shoulder armor, bracers, leg armor, gauntlets: no piece should be identical from the left side to the right. Add a great horned helmet to your orc. Even this should be asymmetrical. Keep one horn intact, and make the other broken off from some previous skirmish.

5 Add in a finished version of the orc's sword, again, keeping even the cross guard asymmetrical. Now your orc is equipped to lead his horde into battle, and your sketch is complete.

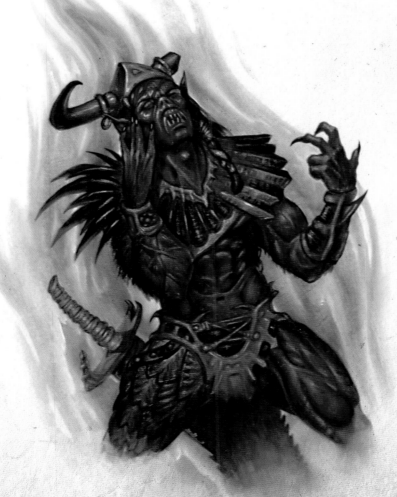

EXAMINING THE FINISHED PRODUCT

I drew some of my inspiration for this orc from *The Lord of the Rings* movies. I liked how earthy and dirty the orcs were in these films, and I wanted to capture that same essence in this piece. I used mainly umbers and siennas mixed with either black or white for the orc's flesh, and similar muted hues for his armor. For contrast, I added a fairly intense greenish background to bring the figure forward.

The Ogre

In European folklore, ogres are gigantic, cannibalistic humanoids of minimal intelligence. These bloodthirsty colossi are quick to anger and always eager to throw their enormous bulk into combat. Though they lack wit, they are social creatures, often traveling in mountainous regions in tribal packs of eight to ten. Since ogres eat large quantities of food, groups with more than ten members would have difficulty finding enough sustenance and would eventually turn on each other in cannibalistic hunger. They are highly territorial and are quick to defend their territory against rival ogre clans, or anything else foolish enough to cross into their lands.

unthinking savagery

Although ogres appear oafish and slow-witted, they are incredibly dangerous adversaries. Our ogre will be the leader of his pack. Like a mighty lion, he has been challenged many times, but never defeated. He carries with him souvenirs of his previous victories, and simple tattoos on his body tell the stories of his past deeds. Of course, if you get close enough to decipher them, you will soon be part of his combat spoils.

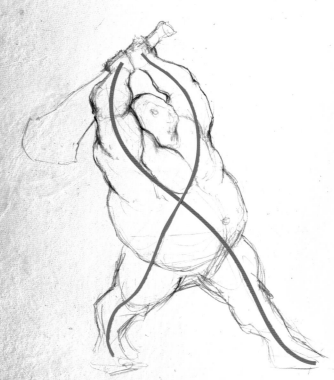

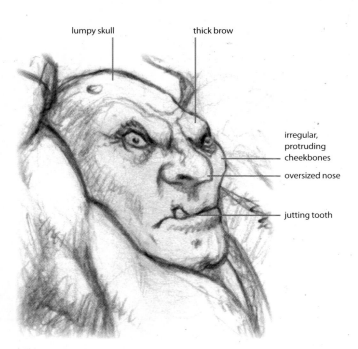

lumpy skull

thick brow

irregular, protruding cheekbones

oversized nose

jutting tooth

1 Block in the ogre in an active pose with his left leg lunging forward as he draws a club over his head. Create crossing gesture lines with steep intersecting diagonals to emphasize this motion. Make sure his club is also set at a steep diagonal. This places the head of the club in a position to act as a strong counterpoint for the Ogre's outstretched foot and makes his pose more believeable.

2 Develop the ogre's head and face, giving him an irregularly shaped skull to suggest his brutishness. Make his balding head somewhat lumpy, not smooth. Exaggerate the thickness of his brow, and give him misshapen cheekbones. Draw his eyes open wide to portray his furious rage, giving him tiny pupils with no irises to make him less human. Draw a bulbous nose, somewhat scrunched due to an intense scowl, with the left nostril flaring. Add the lips last, making them droopy and slightly parted to give way to an errant tooth.

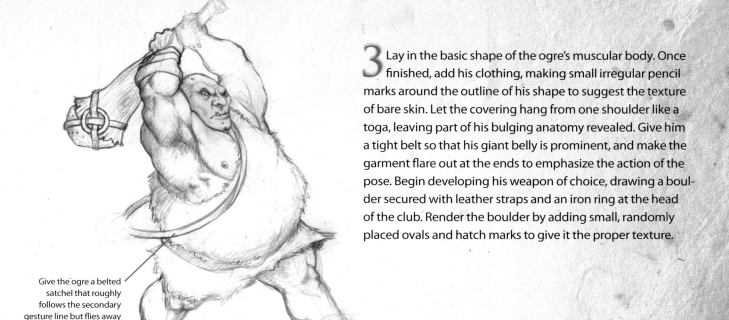

3 Lay in the basic shape of the ogre's muscular body. Once finished, add his clothing, making small irregular pencil marks around the outline of his shape to suggest the texture of bare skin. Let the covering hang from one shoulder like a toga, leaving part of his bulging anatomy revealed. Give him a tight belt so that his giant belly is prominent, and make the garment flare out at the ends to emphasize the action of the pose. Begin developing his weapon of choice, drawing a boulder secured with leather straps and an iron ring at the head of the club. Render the boulder by adding small, randomly placed ovals and hatch marks to give it the proper texture.

Give the ogre a belted satchel that roughly follows the secondary gesture line but flies away from the body. This helps exaggerate the action of the pose.

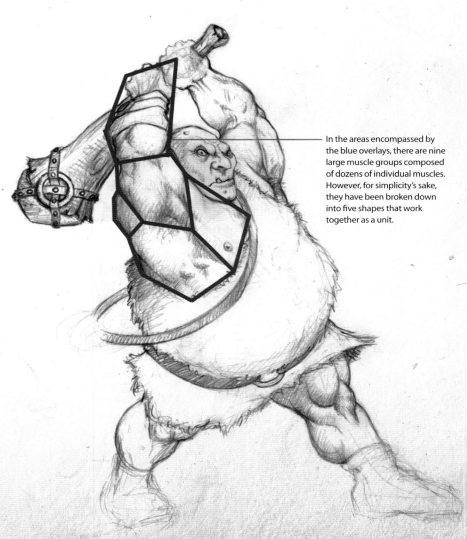

In the areas encompassed by the blue overlays, there are nine large muscle groups composed of dozens of individual muscles. However, for simplicity's sake, they have been broken down into five shapes that work together as a unit.

4 Develop the ogre's massive upper body musculature, making each individual muscle group blocky yet defined. A giant like this is an excellent opportunity to make use of the knowledge of shapes you have acquired so far. Try not to think of every little muscle and sinew as separate entities, but as a connected series of shapes. For example, look at the forearm as a unit that attaches to the upper arm at the elbow, which in turn is surrounded by the shoulder and chest. Remember, the look of these muscle groups varies greatly depending on the angle from which they are viewed. Take a moment to examine these muscles from the angle at which they'll be drawn. Look in the mirror or reference bodybuilding magazines to help you with this.

25

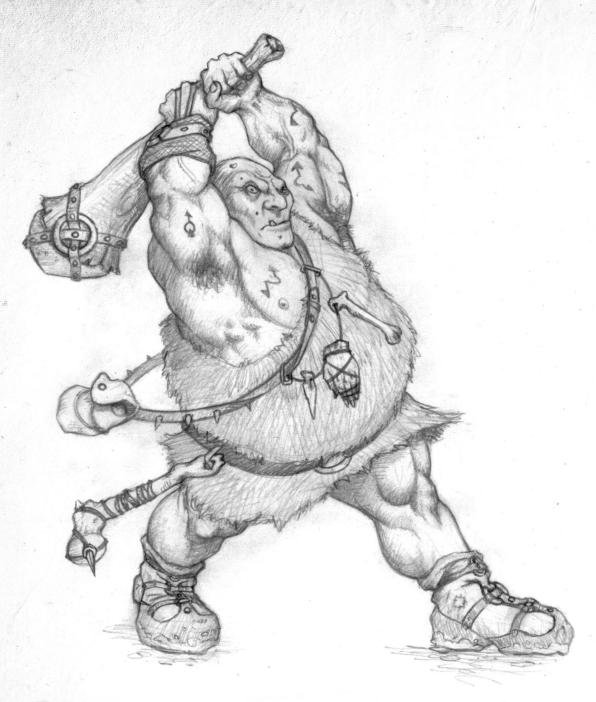

5 Refine the ogre's savage character by adding odds and ends to his attire. Load him up with spikes and leather straps. Add some human body remnants hanging from his satchel strap to reinforce his cannibalistic nature. Hang another bone-type weapon from his belt. An ogre of his ferocity would definitely have more than one weapon. Finally, give him several small and graphically simple tattoos. These would have acted as tribal markers.

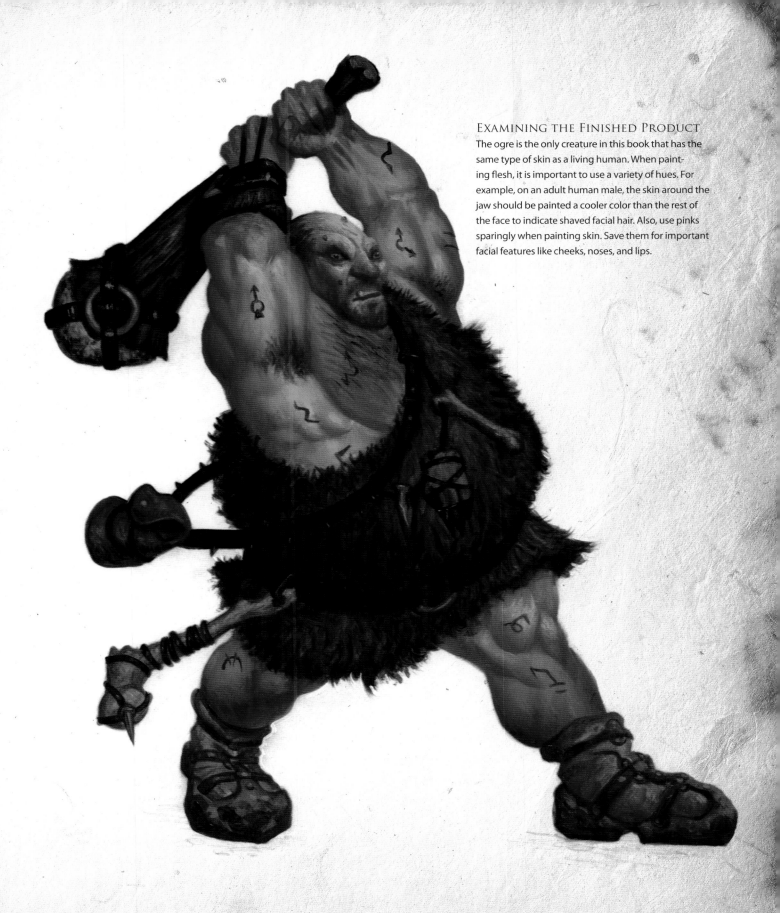

EXAMINING THE FINISHED PRODUCT

The ogre is the only creature in this book that has the same type of skin as a living human. When painting flesh, it is important to use a variety of hues. For example, on an adult human male, the skin around the jaw should be painted a cooler color than the rest of the face to indicate shaved facial hair. Also, use pinks sparingly when painting skin. Save them for important facial features like cheeks, noses, and lips.

The Lich

The lich was once a human being with an overwhelming knowledge of dark magics. In life, this necromancer conducted diabolical rituals whose sole purpose was to reanimate his or her body after it had drawn its last breath. Liches have a certain air of pomposity among the undead, since they were never actually committed to the earth. In fact, they act as if they had never died at all, although their slowly decaying bodies eventually betray their secret.

the richly appointed undead

The uniqueness of the lich within the ranks of the undead grants your imagination a broad field to play on. A lich will often live in death as it did in life. It will dwell within the same house and wear the same clothes. With that in mind, let's make our lich an extravagant 17th-century duchess. The disparity of her rotting flesh in comparison to her elaborate gown and jewelry will make for a powerful image.

1 Lightly indicate the basic lines of an antique sofa, sketching in the lich in a lounging position. One arm should be relaxed and the other should support her weight, the hand holding a long staff. Using your secondary gesture lines as a guide, create the outline of her flowing gown. Let the gown drape above her knee so that the flesh of her right leg is exposed.

2 Draw in an oval-shaped neck frill to frame your lich's face, making sure to leave a wedge-shaped opening in the front. Reinforce the movement within her body with a strong secondary gesture line. Begin to indicate the folds of her gown based on this movement. Folds should range in shape, size, and direction according to their support points, the structures beneath them, and the forces of gravity and thrust.

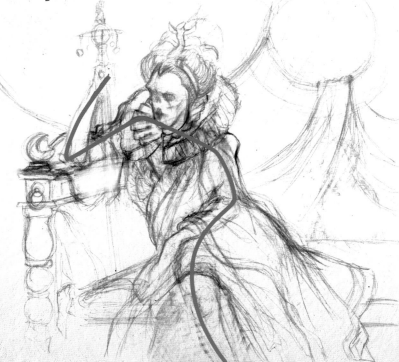

drawing folds in fabric

Because our lich is wearing elaborate apparel, it is important that you learn to render folds in fabric. Doing so will add an element of realism to your drawing and prevent your monster from looking stiff or unanimated.

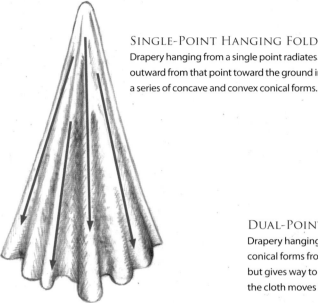

SINGLE-POINT HANGING FOLDS
Drapery hanging from a single point radiates outward from that point toward the ground in a series of concave and convex conical forms.

DUAL-POINT HANGING FOLDS
Drapery hanging from two points radiates the same conical forms from the outermost areas of each point, but gives way to a smoother sweeping movement as the cloth moves midway between the two points.

COMPRESSION FOLDS
When a loose piece of material has support at its origin and its termination, gravity causes compression folds. Compression folds sag and bunch, accompanied by a push and pull dynamic.

ZIGZAG FOLDS
As two ends of a piece of fabric are brought together, a complicated series of ridges and depressions are created. These are called zigzag folds. Zigzag folds are very irregular, but like everything else, they fit the shape of the object they cover.

SPIRAL FOLDS
When material is wrapped around a form, as in a shirt sleeve, spiral folds occur. They follow the contour of the form underneath and are more pronounced where the form bends, like at the elbow joint, for example.

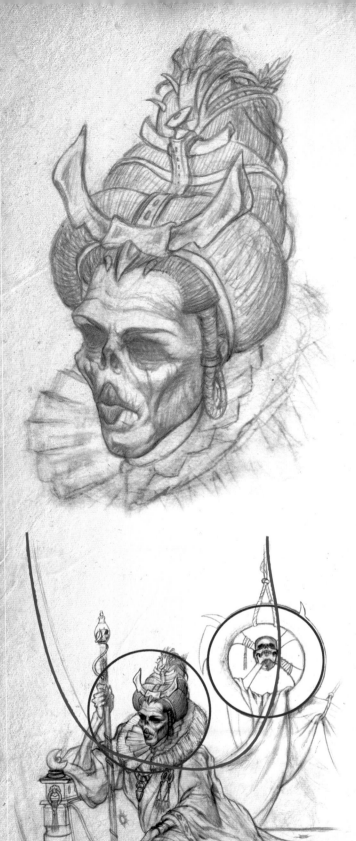

3 Begin detailing the lich's face, placing shadows and highlights to create the illusion of sallow cheeks, sunken eyes, and a decayed nose. Pencil in plump lips in an exaggerated pucker. Keep in mind that the lich would cover up her decaying skin with large quantities of makeup, much like the French aristocracy wore around that same time period. Her face should be a powdery white hue with a bright shade of lipstick to contrast her eerie complexion. Next, pull her hair up into a huge layered bun that is held in place by an elaborate head piece. Remember that the head piece should have supports that follow the cylindrical shape of her hair mass. Ornaments on a body should conform to and compliment the parts they adorn.

4 Add details to the lich's dress referring to the information on page 29 for assistance. Emphasize the skeletal structure of her exposed limbs, stretching her flesh over her bones as tightly as possible. Consult the appendix for the skeletal structure of the human body in order to draw these forms properly. Lay in the background of your choice, applying the same rules of drawing you used for the figure. Use gesture lines that move through the figure and into the background so it seems like the figure is occupying a realistic space. Repeat forms from the foreground into the background to tie the entire image together.

EXAMINING THE FINISHED PRODUCT

I wanted this piece to have the feeling of a Dutch master portrait like those painted by Franz Hals, Rembrandt, and Vermeer. These artists did not have the variety of colors at their disposal that we have today, so they relied on a mastery of earth tones and dramatic lighting to pull off their masterpieces. I tried to do the same in this piece, using primarily umbers and siennas. I saved the brightest area with the most intense hues for the Lich's face and neck ruffle, establishing this as the focal point of the painting.

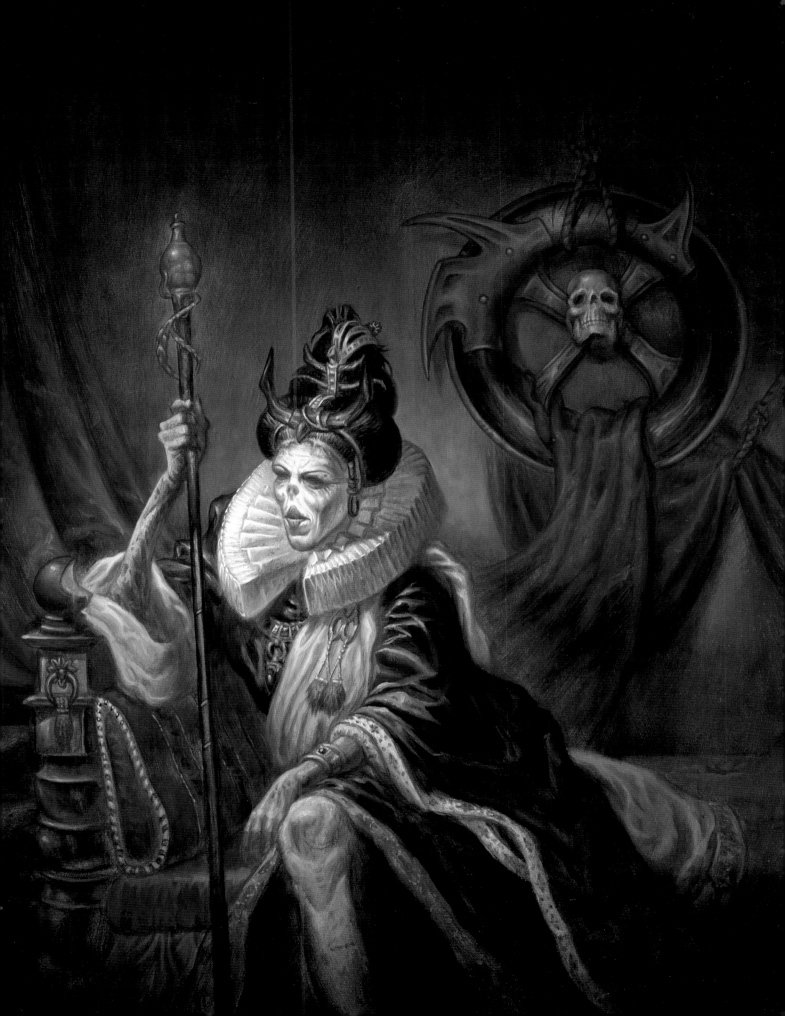

The Demon

The demon is the embodiment of evil, and as such should be a forceful, destructive, hulking being. However, because of the expansive visual history representing these creatures, it is a good idea to establish your demon's personality traits before you begin drawing. For example, is it a soldier fighting for a powerful lord or is it an immense beast of incredible power and rank in the demonic hierarchy? Making these decisions ahead of time will help you chose the most appropriate pose and point of view to represent your creature. Remember, even though people have preconceived notions of what a demon should look like, you needn't be afraid to disregard some of these ideas while keeping those you value in place.

diabolical intent

For this drawing, we will create a fierce and powerful warrior demon whose service to its master is invaluable. To create a truly frightening demon, push your creativity to the extreme, making sure to exaggerate your creature's most horrifying features. For example, a variety of jagged hornlike growths or grotesque skin textures are effective tools in making your creature more intimidating.

1 Create a gesture drawing of a demon charging straight at the viewer. Keep its overall shape blocky to emphasize its immense size and magnitude. Make sure your gesture lines reinforce the creature's movement by receding in space from head to foot.

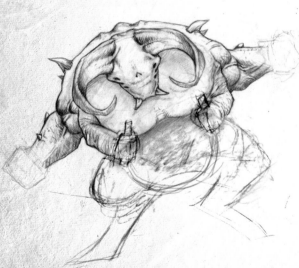

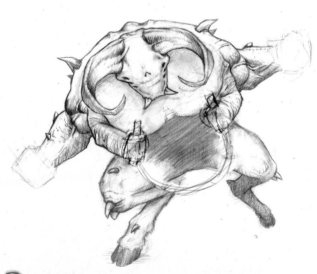

2 Give your demon four arms, each holding weapons, and a set of huge horns that curve downward. Add tiny slits for the eyes and nose and no mouth at all. Flesh out the torso and arms. Give this portion of your demon a thick, leathery hide like that of an elephant or rhinoceros. The demon is lit from above, so its torso should cast a shadow over its pelvis and upper leg region.

3 Balance out the demon's unconventional upper body with a more traditionally demonic lower body. To do this, place the demon's torso on a pair of cloven hooves, a common physical trait among demons. Look at photos of a goat or an elk to get the anatomy correct.

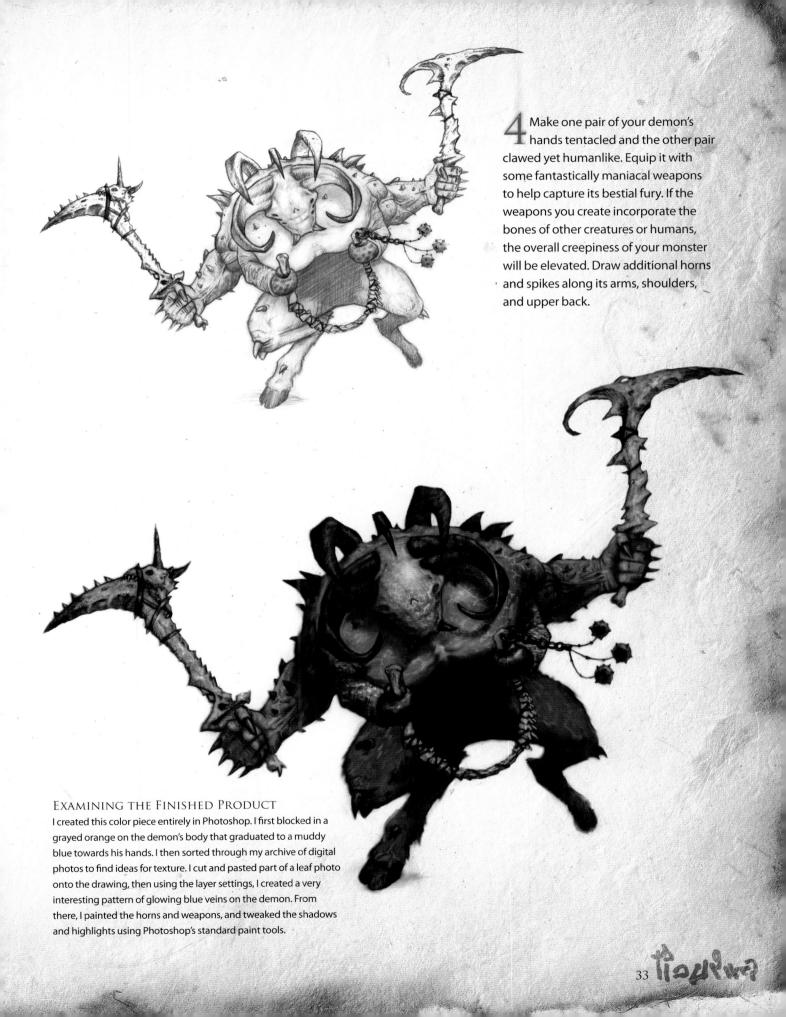

4 Make one pair of your demon's hands tentacled and the other pair clawed yet humanlike. Equip it with some fantastically maniacal weapons to help capture its bestial fury. If the weapons you create incorporate the bones of other creatures or humans, the overall creepiness of your monster will be elevated. Draw additional horns and spikes along its arms, shoulders, and upper back.

EXAMINING THE FINISHED PRODUCT

I created this color piece entirely in Photoshop. I first blocked in a grayed orange on the demon's body that graduated to a muddy blue towards his hands. I then sorted through my archive of digital photos to find ideas for texture. I cut and pasted part of a leaf photo onto the drawing, then using the layer settings, I created a very interesting pattern of glowing blue veins on the demon. From there, I painted the horns and weapons, and tweaked the shadows and highlights using Photoshop's standard paint tools.

The Minotaur

The Minotaur, or Bull of Minos, is the horrendous off-spring of woman and beast. The sole purpose of his birth was to create a savage executioner whose legendary brutality would terrorize humanity. An enormous labyrinth was built to house the Minotaur and his uncontrollable fury. Unable to escape the labyrinth, the rage of the Minotaur reached unimaginable levels. His only joy in life was attained through the hunting and killing of those humans found guilty of crimes against its master.

animalistic brutality

Stylization is key to making an interesting Minotaur, so think carefully before you begin drawing. Our Minotaur will tower above humanity with enormous horns protruding from his head. He should be rough and coarse, wielding a gigantic axe and shield to show he's ready for the hunt.

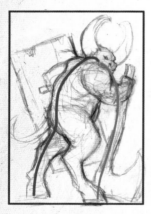
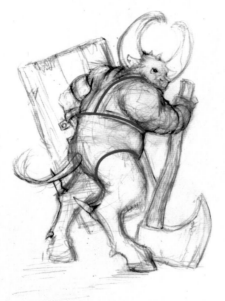
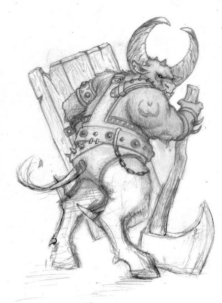

The horizontal line created by the head of the axe and the Minotaur's hooves suggests a strong and sure footing.

1 Draw your Minotaur from a three-quarter rear view so he appears to be looking over his shoulder, sizing up his next meal. Then, block in his large wooden shield and axe, forming a rectangular shape for the overall figure and emphasizing his immovability. Draw your main gesture line so that it curves dramatically where the spine meets the skull. Create the illusion of weight in the Minotaur's shoulders, chest, arms, and horns by pulling his vertebrae forward and downward. Then form a secondary gesture line with the axe handle, bringing the viewer's eye completely around the figure in one motion.

2 Reference a photo of a bull to accurately detail the snout and ears. Make the Minotaur's eyes black and add protruding fangs, then add some spiked horns on his head and legs to make him look fiercer. Next, draw parallel lines on the shield to indicate conjoined wooden slats. Begin laying in the Minotaur's armor, making sure the lines reinforce the conical shape of the creature's limbs and torso. Create bits of fur on his hide by adding a series of sketchy overlapping lines. Remember, it's not important to draw every hair. Just draw a few patches of detailed fur and let the viewer's eye fill in the rest.

3 Add a series of loosely drawn lines all flowing in the same direction to suggest wood grain on the shield. Then draw a few concentric ovals to indicate knots in the wood. Use a series of hatch marks to darken the arm holding the shield, pushing it back spatially. Place some stitching on the armor to give it the look of leather, and add some spikes, studs, and chains to make it more menacing. Brand the Minotaur's fur with a dark mark of your own design. Add detail to the horns, creating the appearance of rough patches with a series of lines that follow the contour of the horn. Darken select lines to create the impression of grooves.

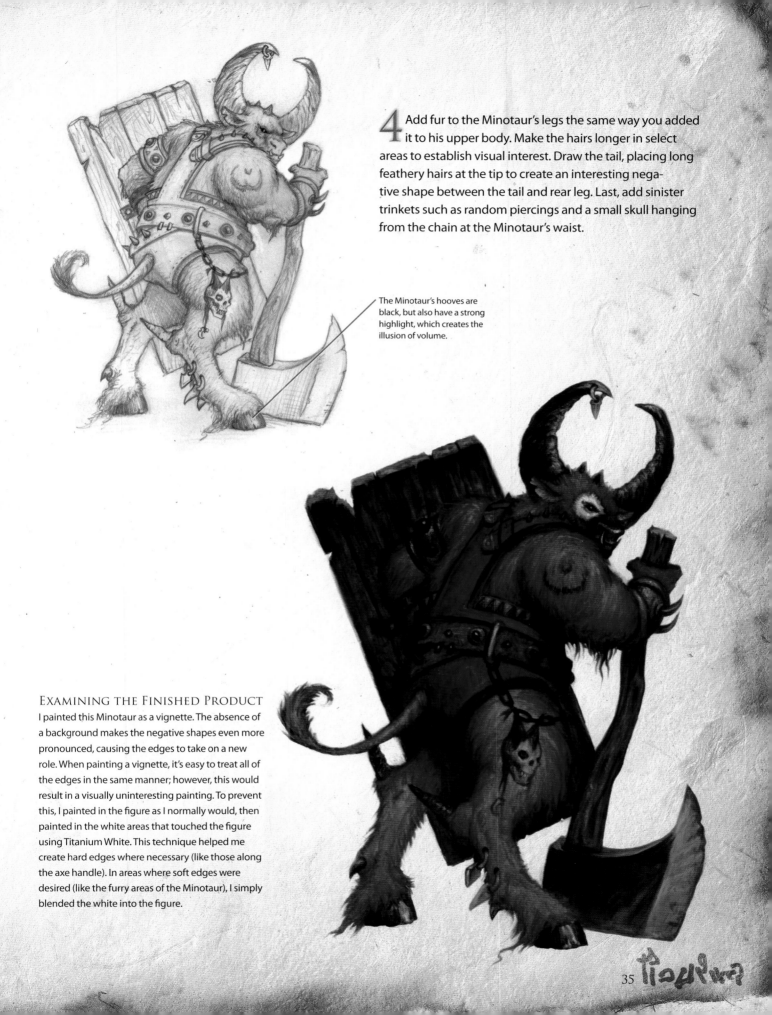

4 Add fur to the Minotaur's legs the same way you added it to his upper body. Make the hairs longer in select areas to establish visual interest. Draw the tail, placing long feathery hairs at the tip to create an interesting negative shape between the tail and rear leg. Last, add sinister trinkets such as random piercings and a small skull hanging from the chain at the Minotaur's waist.

The Minotaur's hooves are black, but also have a strong highlight, which creates the illusion of volume.

EXAMINING THE FINISHED PRODUCT

I painted this Minotaur as a vignette. The absence of a background makes the negative shapes even more pronounced, causing the edges to take on a new role. When painting a vignette, it's easy to treat all of the edges in the same manner; however, this would result in a visually uninteresting painting. To prevent this, I painted in the figure as I normally would, then painted in the white areas that touched the figure using Titanium White. This technique helped me create hard edges where necessary (like those along the axe handle). In areas where soft edges were desired (like the furry areas of the Minotaur), I simply blended the white into the figure.

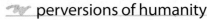

The Zombie

Whether brought back by dark magic or by biochemistry gone awry, the zombie wants only one thing: to feast on human flesh. This unmitigated desire drives a zombie forward at any cost. It feels no pain and will shamble its way through tangles of barbed wire and piles of broken glass just to gnaw on a severed—or attached—limb.

perversions of humanity

An understanding of the human skeleton and surface musculature is of the utmost importance when drawing a zombie. Since its skin is stretched tightly over its muscles, and in some cases is missing altogether, the underlying structures must be drawn properly. Keep in mind, though, that it is appropriate to take some artistic license, or your zombie will look too humanlike. For example, you can make a zombie's eyes small, sunken, dark pits, or huge, round, milky-white orbs. Although each is an exaggeration of the normal human eye, both in their own way lend to the creepiness of the zombie.

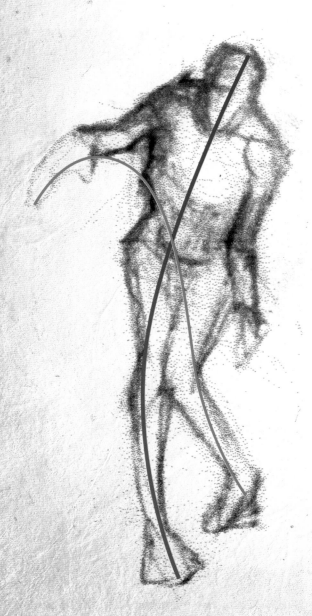

1 Block in the basic outline of your zombie, making sure its gesture reflects the ravages of time spent in the grave. Most of the zombie's weight should be carried by its right leg, which will act as the anchor for this pose. The stiffness of this leg will cause a dramatic tilt in the zombie's pelvis. From there, pitch its torso forward drastically to add to its awkward gesture. Make the zombie's limbs move at odd angles, and make its weight shift awkwardly on unstable joints connected by decrepit musculature.

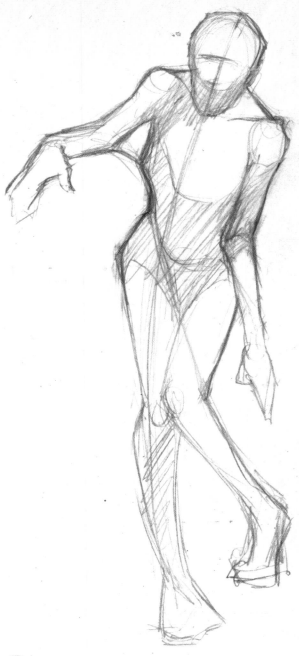

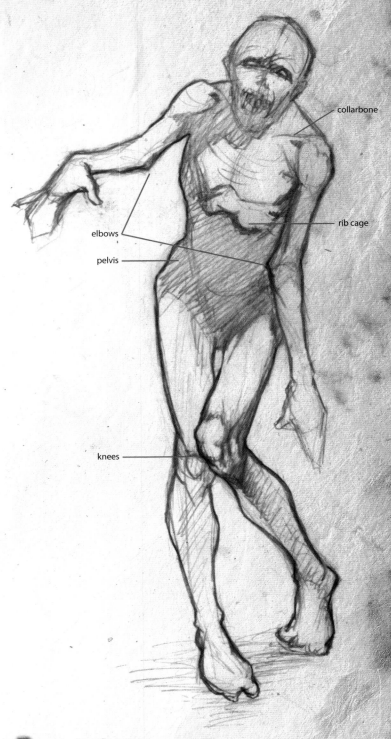

collarbone

rib cage

elbows

pelvis

knees

2 Make your zombie five and a half heads high (as opposed to the normal human male standard of seven heads high) to emphasize the fact that its torso is pitched forward. This foreshortening of the torso adds to the zombie's awkward, lurching posture. Draw attention to the zombie's head by making it large for its frame. This helps reinforce the feebleness of its decrepit body.

3 Indicate the structure of the zombie. Focus on points where the skin pulls tightly over its frame, including the collarbone, elbows, and knees, and exaggerate the bone structure in these areas to emphasize the skeletal nature. Add shaded pencil marks to suggest concave features or areas that will fall in the shadows, such as the stomach and left shoulder. Mark the position of the zombie's eyes, nose, and mouth in preparation for adding details in later steps.

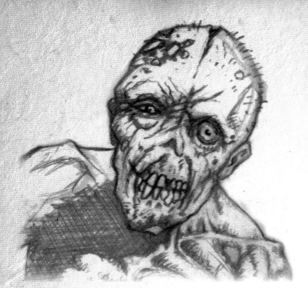

4 Create a lip area that has been eaten away by insects and worms, revealing the zombie's teeth and gums. Make sure you don't just draw a straight horizontal line to indicate the space in which the upper and lower teeth meet. This area, comprised of the maxilla on top and the mandible on bottom, should be treated as a rounded surface that the teeth wrap around. Rather than add a fleshy nose, draw a hollowed out nasal cavity where a nose once existed. Add bunches of sagging flesh around the eyes, leaving the left eye without an eyelid. Having an eye that never blinks makes the zombie more frightening, as its prey can never escape the blood-thirsty stare of that one cold, dead eye. Finally, place random scabs and sores along the skull to suggest decomposition.

5 Detail the zombie's flesh, remembering to keep it pulled tightly over the musculature. Choose random areas for bruises, scars, and holes rotted in the flesh. Throw two cast shadows from its head onto its chest and from its upper torso onto his lower abdomen and pelvis region. Where large areas of flesh have rotted away, such as on the shins, let some of the tibia show through to add to the level of decay. When handling the feet, remember to think of them as an overall shape with a solid base first before worrying about each little toe.

tibia

EXAMINING THE FINISHED PRODUCT

To paint this composition, I first printed out the final sketch and adhered it to a piece of masonite with gel medium. I then applied a variety of water-based dyes using an eyedropper. I sprayed the drops with a spray bottle, causing the colors to swirl into each other and pool in interesting ways. Once dry, I scanned the image and opened it in Photoshop, where I refined the painting. I used a wide range of color in the zombie's flesh to indicate the various states of decay and bruising. I kept the colors muted and darker at the zombie's feet, and increased their saturation and brightness as they moved toward the head to draw the viewer's eye to the focal point.

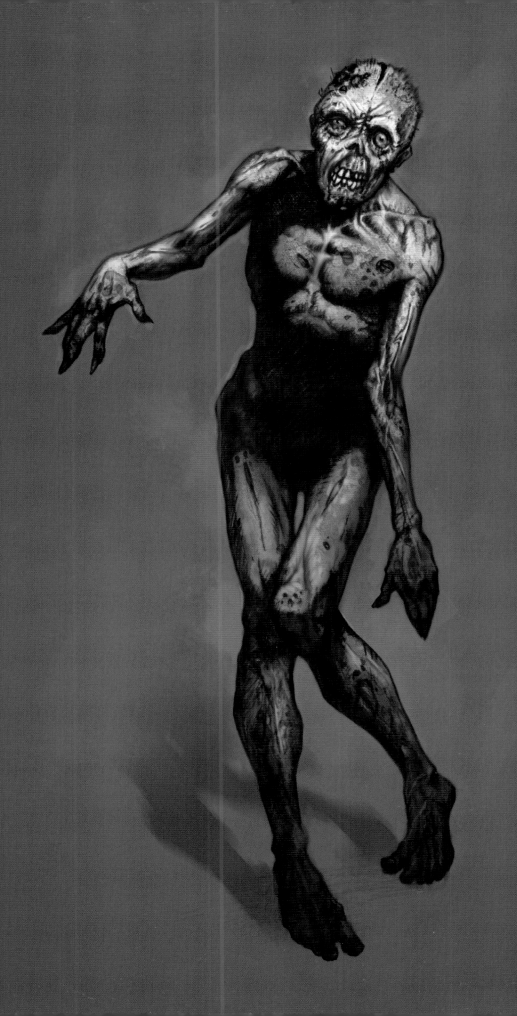

The Vampire

Almost every region of the world has some form of vampire in its folklore. With so much history behind them, and their popularity in modern fiction and cinema, it can be a challenge to come up with an interesting and unique-looking vampire. It is important to push several components of design to the extreme in order to make our vampire more visually interesting. The following elements will help produce an arresting and original vampire: creating an overall triangular shape, emphasizing batlike features, and implementing sharp contrasts.

visage of a blood seeker

Throughout history, vampires have filled many roles. They have been proud counts, pompous nobles, disgusting sewer dwellers, or the guy next door. In all of these forms, though, they have remained relatively human looking. We are going to break from this tradition, making our vampire more animalistic in nature. He will maintain an air of aristocracy and reek of fiendish savagery all at once.

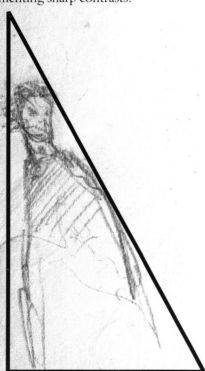

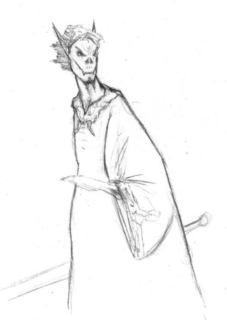

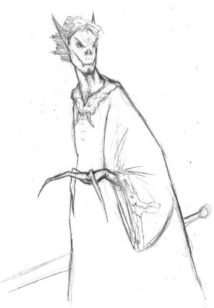

1 Lay in the basic shape of the vampire's figure, starting with a simple triangle. (Note that you will break the lines of this triangle sparingly throughout the drawing process, the end result being a bold and striking design.) Repeat this same shape throughout the image at different sizes and angles to give the figure an overall unity. Before moving on, lightly indicate the placement of facial features and clothing to fill out the shape fully.

2 Exaggerate the vampire's batlike qualities, substituting human features for those of a bat, the vampire's alternate form. Repeat the triangular shape to develop long pointed ears, a batlike snout, an angular jaw, and facial hair. Make its teeth small and pointed and its eyes dark to further mimic a bat. Vaguely suggest the outline of the vampire's sword.

3 Define the exposed left hand, adding a single clawed finger extending from the original triangular shape. Then add subsequent fingers that emulate sharp spikes breaking through the hand like a fang breaks through supple neck flesh.

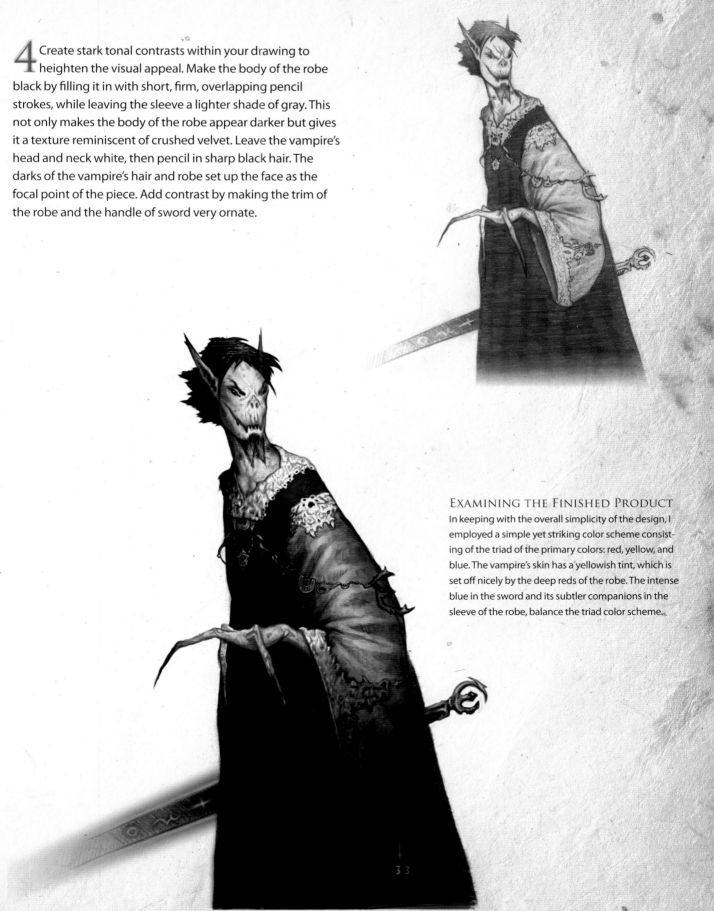

4 Create stark tonal contrasts within your drawing to heighten the visual appeal. Make the body of the robe black by filling it in with short, firm, overlapping pencil strokes, while leaving the sleeve a lighter shade of gray. This not only makes the body of the robe appear darker but gives it a texture reminiscent of crushed velvet. Leave the vampire's head and neck white, then pencil in sharp black hair. The darks of the vampire's hair and robe set up the face as the focal point of the piece. Add contrast by making the trim of the robe and the handle of sword very ornate.

EXAMINING THE FINISHED PRODUCT

In keeping with the overall simplicity of the design, I employed a simple yet striking color scheme consisting of the triad of the primary colors: red, yellow, and blue. The vampire's skin has a yellowish tint, which is set off nicely by the deep reds of the robe. The intense blue in the sword and its subtler companions in the sleeve of the robe, balance the triad color scheme.

The Goblin

The origin of the goblin is shady at best. The word itself may be based on the Greek word *kobaloi*, which means "evil spirits." Goblins are troublesome, hideous scavengers that eke out an existence in forests and mountain areas while fighting among themselves and attacking unfortunate passers-by. Any armor or clothing they wear is either stolen from someone else or pieced together from items indigenous to their surroundings.

at the feet of evil

To capture the essence of this loathsome beast in a unique way, let's pose our goblin as though a camera were at his feet. Doing so creates what is known as *forced perspective*. When drawing in forced perspective, everything becomes dramatically smaller as it moves away from the camera to heighten the visual effect.

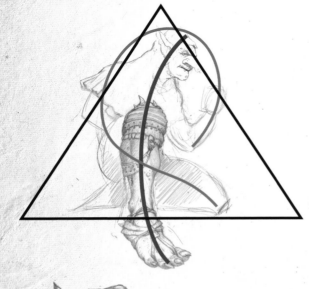

1 Draw the goblin in a kneeling, hunched position ready to pounce on an unsuspecting traveler. Using his left leg as a horizontal base, fit his body into a triangular shape. Bring the lower half of the goblin's right leg out of this shape, moving it closer to the viewer and exaggerating its size to create forced perspective. Make his head much smaller in comparison to his forward foot to reinforce this perspective. Allow the goblin's rear leg to fall into shadow around the pelvis area, and eliminate any negative spaces between the calf and hamstring, creating the illusion that the goblin is firmly grounded on a strong base. Add his attire, complete with a hooded cloak to accentuate the overall triangular shape of the pose.

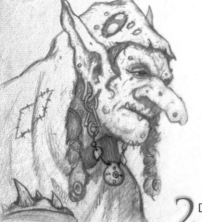

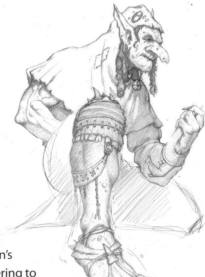

2 Draw a vastly over-sized hooked nose and a pair of huge pointed ears, both covered with warts and scabs. Create a lipless mouth area punctuated by misshapen and random teeth to add to his overall grotesqueness. Finally, draw a scruff-covered chin and frame the head with dirty, crusty braids of thick, coarse hair.

3 Detail the goblin's arms, remembering to keep them small in comparison to the lower part of his right leg. Give your goblin three fingers only. Such non-human characteristics on a humanoid creature always make it creepier. Finish shaping the garments on his upper body by using a dual point hanging fold across his shoulders and a combination of compression and spiral folds on his left arm.

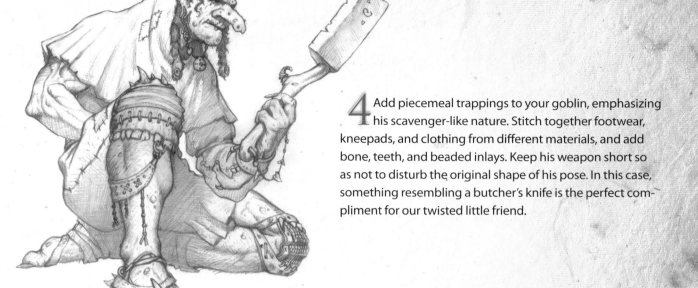

4 Add piecemeal trappings to your goblin, emphasizing his scavenger-like nature. Stitch together footwear, kneepads, and clothing from different materials, and add bone, teeth, and beaded inlays. Keep his weapon short so as not to disturb the original shape of his pose. In this case, something resembling a butcher's knife is the perfect compliment for our twisted little friend.

EXAMINING THE FINISHED PRODUCT

I believe goblins should be green. They don't have to be traffic-light green, but their skin tone should contain some sort of greenish shade. In painting this goblin, I added warmer areas of color to the skin where it is stretched tightly over bones (like in the knuckles of the fingers) and in areas where a large number of blood vessels are close to the surface of the skin (like in the cheeks and nose). This creates a variety in color that makes the piece more interesting and more realistic looking. The only cases in which this rule does not apply to humanoid creatures is if they are undead and no longer have functioning hearts to pump blood to the aforementioned areas.

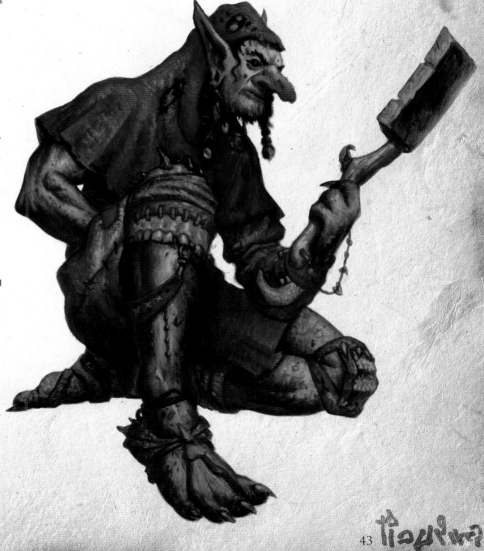

The Oni

An oni is a Japanese ogre or demon. They are the fierce horned guardians of hell, and they gladly deliver suffering to its wretched inhabitants. The sound of shattering human bone is a particular favorite of the oni. It has devised hundreds of ways to achieve this sound, most of which are entirely too gruesome to describe here. At times, onis have been known to even crack their own bones in order to alter their physiology for some diabolical purpose.

devil from the east

In Japanese folklore, the oni had an odd number of eyes and was often covered with tiger skins. In keeping with this theme, let's place a third eye on our oni's forehead and add some tiger stripes to his forearms. Remember, the oni is the soul-crusher of the netherworld and should therefore be lean and muscular. Rage and joy are the same emotion to an oni, and this will be apparent in every detail of our monster.

1 Block in the oni's basic stance, placing the viewer's eye above as he looks down into the vast nether regions of hell. Draw his arms raised and his mouth open in a shriek as though he were welcoming his newest victims. Let the arm that is closer to the viewer be larger than normal, and overlap diagonals so that it seems as if the oni is actually coming out of the picture plane.

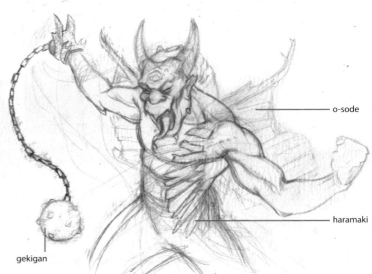

o-sode

haramaki

gekigan

2 Add a Japanese flair to your drawing by incorporating traditionally based samurai armor, including modified shoulder armor, or *o-sode*, and a torso protector, or *haramaki*. Lay in the armor by creating a series of overlapping horizontal slats laced together with thick cord. It's not necessary to draw the armor exactly as the samurai wore it. Use its design as a base, and create armor that suits your needs and the overall gesture of the figure. Replace the oni's right hand with a studded ball and chain, or *gekigan*, to add to the pose.

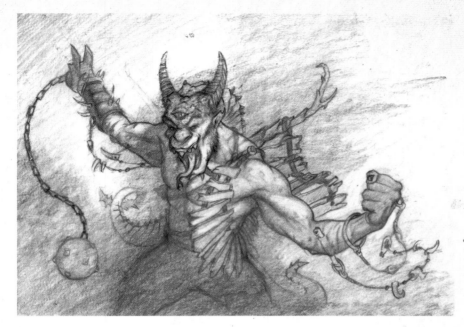

3 Place a larger third eye in the center of the oni's forehead. Draw bony skull ridges that flow into a long spiny tendril along a line that sweeps toward the ball and chain, adding even more motion to the figure. Use the side of your lead to shade the legs in a sketchy manner, making them furry and dark. Add tiger stripes, which serve as tattoos, to the oni's arm. Give him several grotesque piercings, thrusting entire objects through his limbs and attaching them by chains and chords to other oddly placed piercings. Adorn these piercings with bones and other trinkets taken from victims, hinting at the oni's vicious nature.

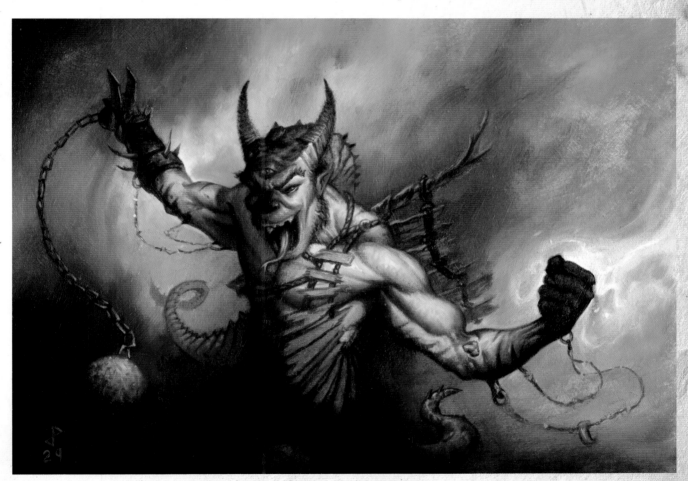

EXAMINING THE FINISHED PRODUCT

Since the Western concept of hell always includes fire and seas of blood and lava, I wanted to try a different approach to painting this Eastern hell-dweller. I painted the background wet-into-wet with oils, replacing the traditional red and orange hues with shades of blue and green. The slower drying time of oils allowed me to push the colors into one another and mix them directly on the image with ease.

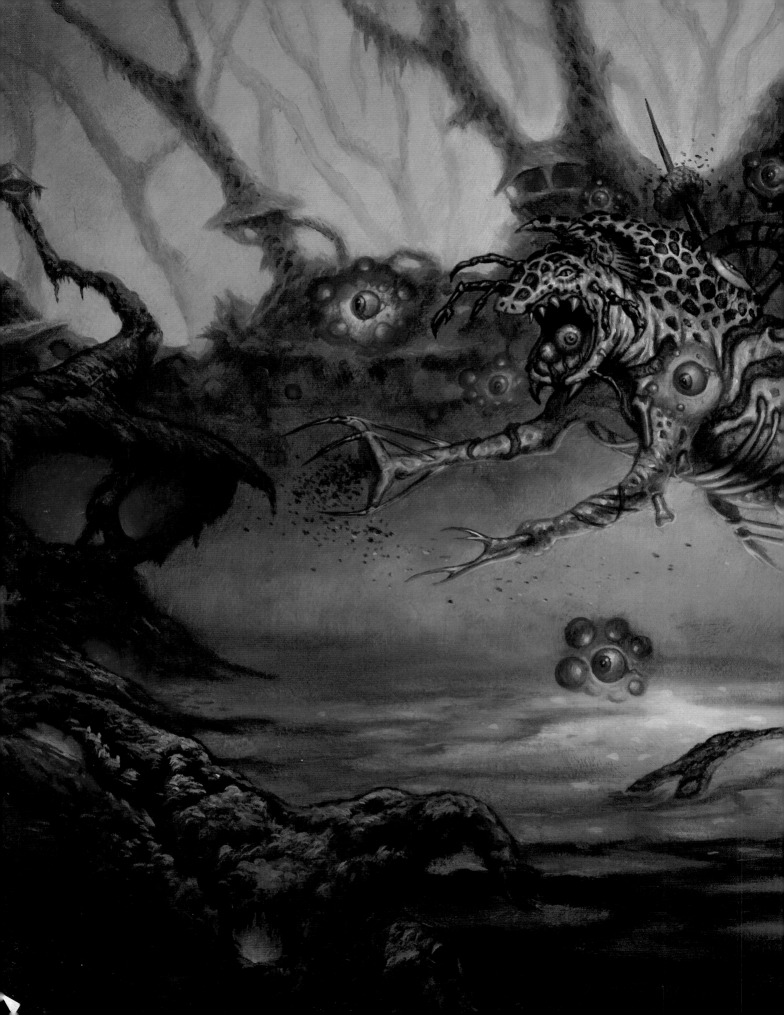

REPTILES AND AQUATIC CREATURES

F ear of snakes and other reptiles has a special place in human history. Western theology is filled with representations of evil in the form of snakes and their winged counterparts, dragons. Even the Bible casts a serpent at the root of man's fall from grace, as it was a snake that lured Adam and Eve into eating from the Tree of Knowledge. And just as man fears reptiles, he is equally frightened by aquatic creatures that dwell in the deep, dark abyss of open waters. After all, we know very little about life on the ocean floor, and there is nothing more frightening than the unknown. And why shouldn't we shudder at the thought of these mysterious sea creatures? They thrive in an areas that we couldn't survive in for more than a minute or two before our lungs filled with water or were crushed by the overwhelming pressure of the sea. That alone is enough to make even the bravest of souls cower.

The Hydra

The Hydra has its roots in Greek and Roman mythology but was later adopted by Christianity to represent the beast of the apocalypse. Throughout its many incarnations, the Hydra has been described as having anywhere from three to one thousand serpentine heads growing out of its body. It is a formidable enemy, as the severing of any of its heads will only result in the regeneration of a new and perhaps deadlier one. Mouth dripping with poison, the Hydra's presence means certain death for those within its reach.

multiple heads, multiple solutions

The Hydra presents us with a unique dilemma. With so many heads, how will we choose a focal point for our drawing? There are a couple of ways to approach this problem. We could treat the heads as part of a larger unit, and have them all follow roughly the same gesture line. Likewise, we could have the heads moving in many different directions and make only one of them the main focal point through the use of size, position, and contrast. For the purposes of this piece, we will opt for the latter.

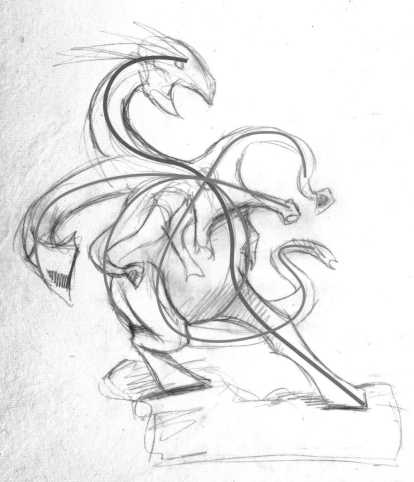

1 With the beast reared up on its hind legs, create a long, sweeping primary gesture line that runs from the tip of what will be the Hydra's main head all the way to the end of its most outstretched foot. At about its midchest, select a point through which all of the secondary gesture lines for the arms and smaller heads will flow. The size and shape of its various necks and heads should cover the gambit, as long as the head you want to be the center of attention remains the largest.

2 Make each of the longer necks that stretch above the Hydra's shoulder blades different in type and texture. Each head should be of varying size and have a different stylistic feel to it. Keep some of the heads traditionally dragonlike, and others strange combinations of birds, turtles, and other aquatic creatures. To make the Hydra even more extraordinary, put roaring heads where its hands would be, and add yet another head to the end of its tail. This brings our head total to ten, yet the head that is the focal point of the piece is still clear because of its much larger size and its position at the top of the composition.

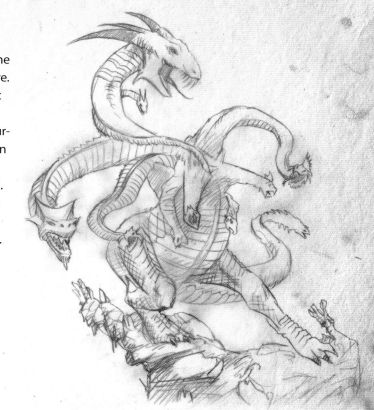

3 Add details to your Hydra, studying pictures of various animal textures for inspiration. Use reptile, insect, and fish picture books as references for your drawing. On its many heads and upper appendages, mix and match textures, blending one into another. For example, on the neck of the main head, start with a pythonlike surface and pattern at the base, then transfer to a hard, overlapping scaled structure like that of an armadillo near the head. Even feathered areas are allowed when creating a vile monstrosity such as this, so make one of the heads on the Hydra's right-hand side mimic a chicken or bird.

49

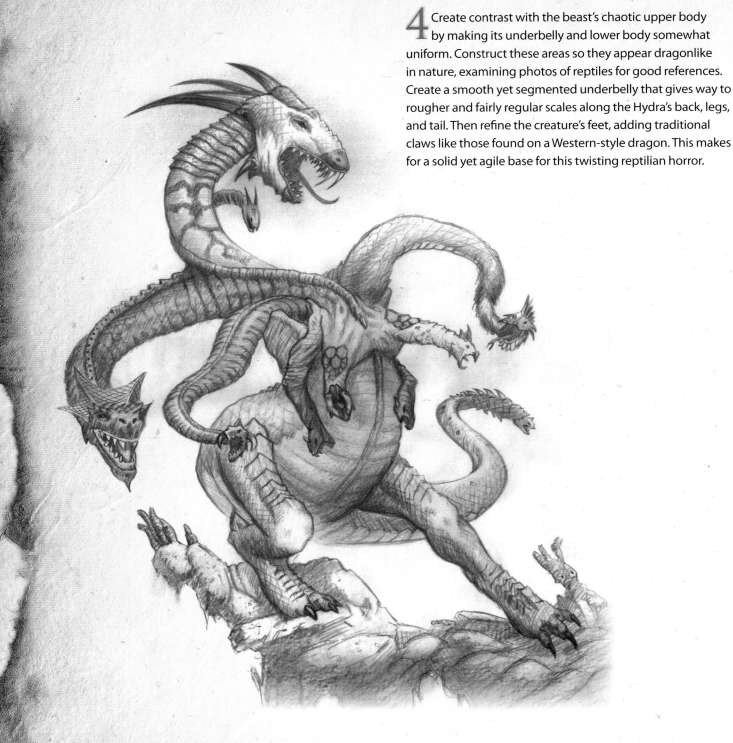

4 Create contrast with the beast's chaotic upper body by making its underbelly and lower body somewhat uniform. Construct these areas so they appear dragonlike in nature, examining photos of reptiles for good references. Create a smooth yet segmented underbelly that gives way to rougher and fairly regular scales along the Hydra's back, legs, and tail. Then refine the creature's feet, adding traditional claws like those found on a Western-style dragon. This makes for a solid yet agile base for this twisting reptilian horror.

Examining the Finished Product

I used a unique color for each of the Hydra's heads to further emphasize their design differences. I made use of nearly every color on the color wheel when painting this beast. I added large amounts of white to the blue background in order to balance out all of the highly saturated colors in the foreground. I gradated the blue into a muted purple in the lower right and added splashes of green to the bottom of the piece to tie the foreground and background together.

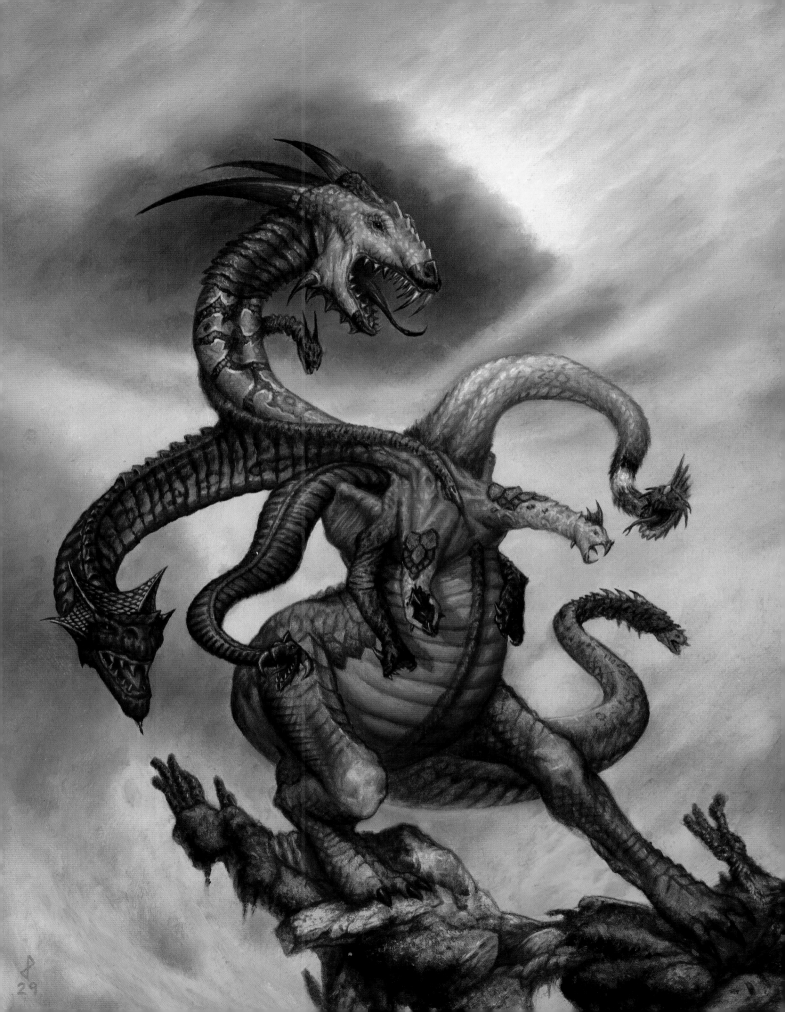

The Kiyo

A reptilian creature of medieval Japanese lore, the Kiyo was spawned when a young girl set out to seek revenge against a novice monk who jilted her. To satisfy her rage, she studied the secrets of dark sorcery and transformed herself into this hideous beast. After exacting her revenge, the Kiyo never again returned to her human form; rather, she revels in her monstrous powers and delights in torturing the bodies of those who remind her of her former lover.

a punch of perspective

The architecture in this piece presents you with the challenge of rendering *perspective*, or the appearance of things relative to one another as determined by their distance from the viewer. For this drawing we will utilize the most basic setup known as *one-point perspective*. We begin with a horizon line, or the line where the landscape ends and the sky begins. All lines that run in the same direction as the horizon remain parallel to each other, while lines running perpendicular to the horizon converge toward a single point on the line called the vanishing point. To create the effect of movement in our composition, we will slightly tilt the horizon line, using this diagonal as guide for the rest of our drawing.

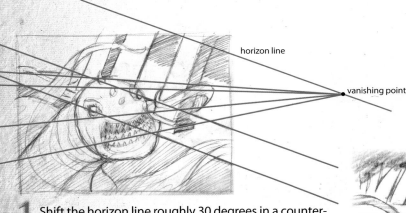

horizon line

vanishing point

1 Shift the horizon line roughly 30 degrees in a counterclockwise direction. Block in both the Kiyo and the background, relying heavily on intersecting diagonals to create the illusion of movement. The Kiyo's body should appear as an undulating blob, her head and neck modeled after a worm and her mass of writhing tentacles resembling those of an octopus. Draw the Kiyo's body running off the lower left-hand side of the page at a 45-degree angle, and make the neck and head erupt violently from that same corner of the drawing at a perpendicular angle to the body. The tentacles, although curved and winding, should lead the viewer's eye toward the vanishing point.

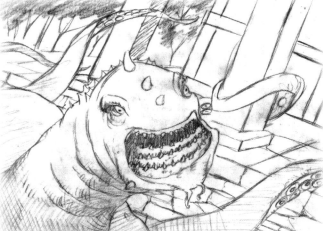

2 Keep the architectural lines that run along the horizon line parallel to each other in order to make the structure seem more solid. Create the background trees at the top of the picture. Use the side of your pencil to rough in some irregular-shaped strokes that will serve as the leaves, then pull down some branch lines that converge into thin tree trunks. Shade the underside of the brows of the Kiyo's eyes to set them back into its skull. Use a variety of hatch marks on the underside of the neck to establish shadows.

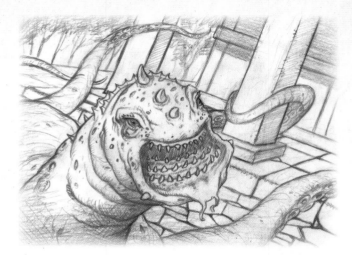

3 Add interesting elements to the Kiyo's head, offsetting it from the fairly basic body. Give it a huge gaping mouth with multiple rows of sharp sharklike teeth to establish an element of ferociousness that a more standard mouth could not achieve. Make the eyes deep set with heavy lids and brow ridges. Add rows of sharp, spiny fins at the crest of her head and along her neck to echo the shapes of the teeth. Finally, add some thick horns running down the center of the forehead and around the jaw to give the Kiyo the soul-crushing visage we are looking for.

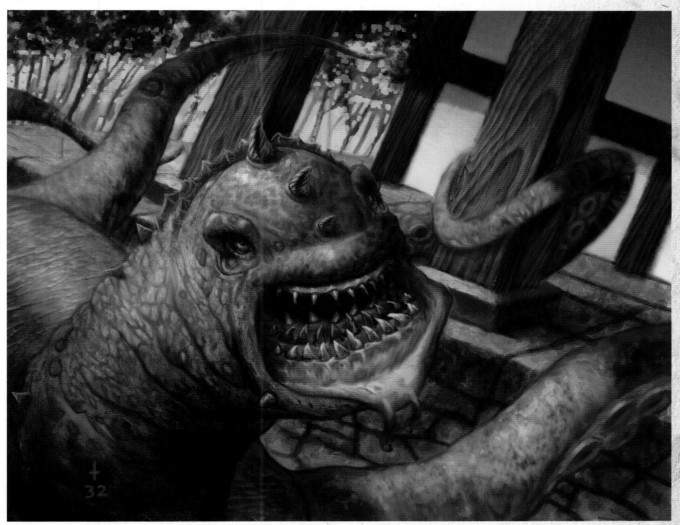

EXAMINING THE FINISHED PRODUCT

This is another example of a piece I started painting traditionally, then finished up digitally. I had just visited an aquarium, and I had taken tons of photos of the wildlife. This supplied me with a rich variety of textures to use on the Kiyo. Sampling textures from photographs is a common trick used by digital artists. You can apply and alter these samples in Photoshop in a multitude of ways, bringing a new level of creativity to your work. The key is to not become completely reliant on the photos for all aspects of the work. Doing so only limits creativity and replaces elegantly drawn figures with stiffly posed photos.

Arctic Wyrm

In Germanic tradition, the word *worm*, meaning serpent, is used to describe the dragon. The Old English equivalent to this same concept is the word *wyrm*. Of course, in modern English a worm is something much different from a dragon, but it can still be used as the basis for the creation of a tremendous beast. If handled properly, you can twist the simple tubular shape of the earthworm into a massive, earth-shaking devourer.

 ruler of the frozen tundra

When trying to visually convey the enormity of a creature, it is a good idea to have its body break the edge of the picture plane. This suggests the creature is so large all of it can't be taken in through the normal field of vision. This works especially well for long snakelike creatures, as it is easy to twist their bodies in and out of the picture. Let's try this concept with our wyrm to suggest its massive size and stature.

To further illustrate the fearsome nature of our wyrm, let's change the setting from the traditional earthen scene to one of barren permafrost. Now, not only is our beast enormous in size, it also exists in the lone surviving colossus of an otherwise lifeless region.

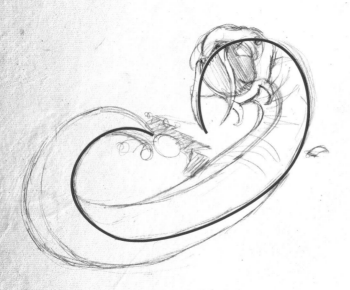

1 Lay in the basic shape of the wyrm, placing its rearing head in the foreground of the frame. Allow its body to move out of the picture at one point and come back into it at another. To portray this accurately, visualize a complete gesture line that moves out of the frame. Before moving on, lightly indicate details on the wyrm's head. Give it an open mouth to reveal large pointy tusks, and mark a spot on the right side of the wyrm's head where you will later place the visible eye.

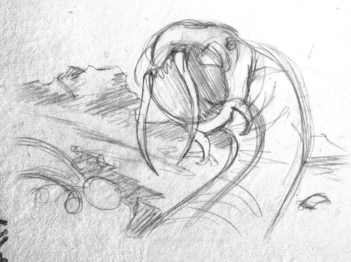

2 Sketch icy mountains in the background along a diagonal horizon line to add drama to the composition. Establish glacier and ocean elements in the foreground and middle ground, plotting the wyrm's path through them. Make the wyrm's body break in and out of the ice in fluid arcs that reduce in size as it recedes into the background.

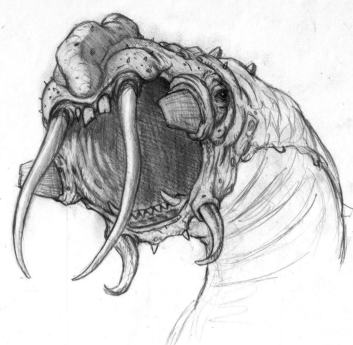

3 Add features to the wyrm's head as though you were wrapping them around a cylinder. Detail the visible eye using a picture of a lizard for good reference. Imply walruslike characteristics to suggest the feeling of a creature that dwells in a subzero climate. Make its hide rough and lumpy with the occasional bristly whisker, and draw in several sets of tusks of differing sizes and shapes protruding from its mouth and jaw.

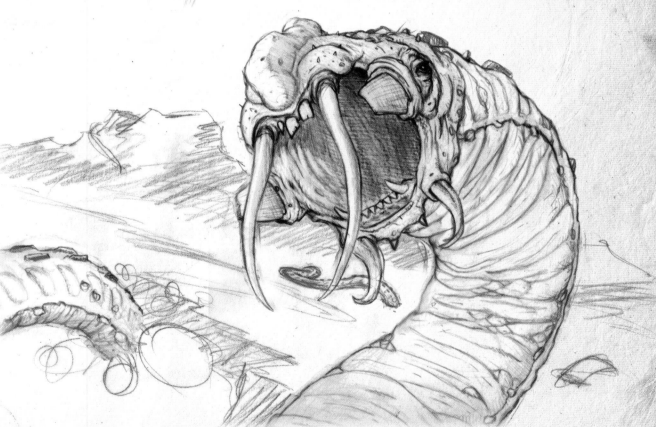

4 Break the wyrm's body into upper and lower portions with the middle segment obscured by the ice. Make the upper portion thick and impenetrable, rendering it as though it were made of a flexible stone substance. (This may sound like a contradiction in terms, but this is a fantasy monster so you can take liberties in such cases.) Then add contour lines on the wyrm's underbelly to create wrinkles in its skin, giving the wyrm a more solid three-dimensional feel.

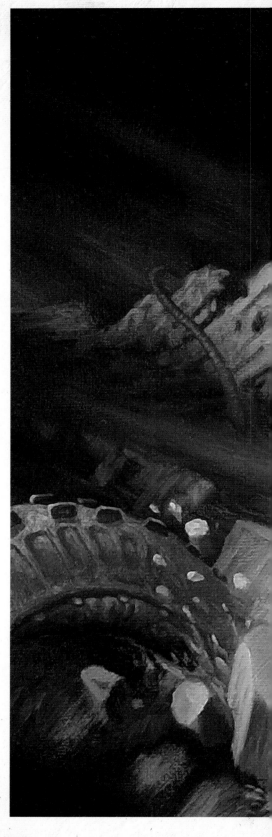

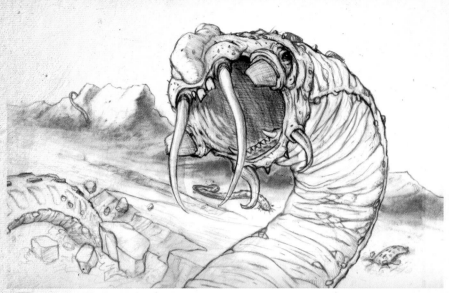

5 Finish the composition by refining the mountains and ice. Use the side of a wood-cased pencil to fill in cast shadows formed by the icy ridges and crevices of the mountains in the background. Draw a thick ridge where the ice meets the water, creating large chunks of broken ice where the wyrm's body thrusts up between the two.

EXAMINING THE FINISHED PRODUCT

I was presented with an interesting challenge in painting this piece. Although the setting was a frozen tundra, I wanted black to be the dominant color. As such, I made the sky black and cloudy, setting an ominous mood for the piece. I also chose to suggest a setting sun out of the picture frame to the left. This allowed me to use a strong cast shadow on the wyrm where its neck moves toward the viewer. The setting sun gave me the ability to paint the snow-covered mountains in the background an intense, warm color. This is possible because as objects recede toward the horizon, they are affected more and more by the atmospheric conditions. In this case, the white snow of the mountain is reflecting the light of the sun like a mirror. It works well as a contrast to the more muted tones of the ice in the foreground and helps tie the wyrm to the background, unifying the piece.

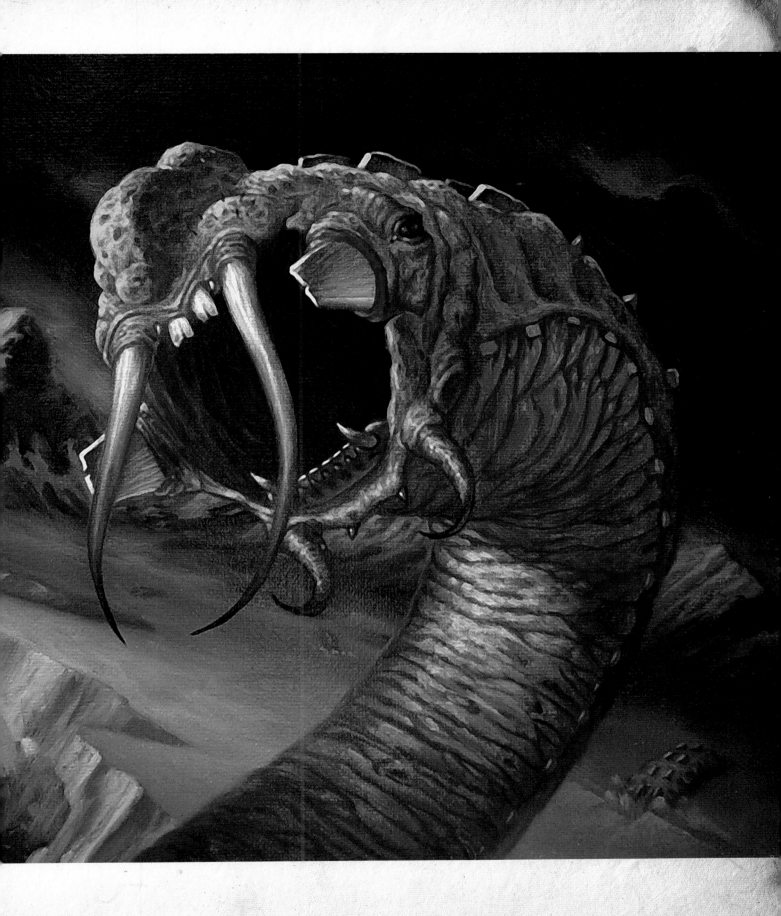

The Leviathan

Condemned to the blackest depths of the ocean, the Leviathan patiently awaits a time when the servants of evil will summon it forth to wreak havoc on the innocent and conquer the world. The tiny amount of light that penetrates this massive creature's domain glints dully off of its lamenting eye. This same eye will one day burn with a light of its own, a light so intense as to lay waste to entire cities, incinerating populations before they can even begin to fear.

lord in the kingdom of eternal night

The Leviathan is one of the most ancient and massive creatures in this bestiary. To capture these elements visually, it is imperative that we see only a small portion of the beast. Also, the Leviathan should be somewhat formless. By this I mean that there should be no distinctive skeletal structure to its body. Despite its size, it should move about the darkness like a coarse-skinned, tentacled jellyfish.

1 Create the basic outline for your Leviathan, making the base of its body large and bulbous and its tentacles long and flowing like those of an octopus. Make sure that you allow the central mass of this monstrosity to run off the page at the bottom and the sides. This suggests that the unseen portion of the Leviathan might continue on for infinity into the deep waters it inhabits.

2 Treat the Leviathan's tentacles and head with special attention, adding minute details to define the creature. Let its tentacles undulate through the murky depths like seaweed, moving in and out of the picture frame and overlapping one another. Add a variety of growths and protrusions to the tentacles. Make some of these growths sharp and jagged to add to its menacing nature, but make others appear more organic and natural to its underwater environment. Look at pictures of deepwater fish and plant life to get a feel for the textures and movements common in this setting.

3 Add giant fins and gills on the basic head structure you have already roughed in. Compliment these with a variety of small tubules and squid-like tentacles around the Leviathan's mouth and forehead. Make the mouth itself a small rounded opening with a rim of oddly shaped teeth, and establish two small black eyes. Next, add several blowholes with tiny air bubbles floating up from each hole. Normally, sea creatures do not have both gills and blowholes, but the Leviathan is a special case. Its creation defied evolution, and though it is confined to the deep (where gills are a necessity), it will someday return to the surface, lashing its mighty tentacles and breathing the air mankind has taken for granted for so long.

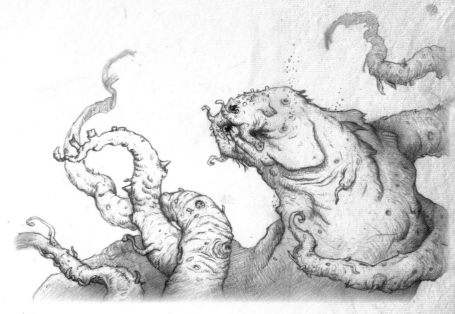

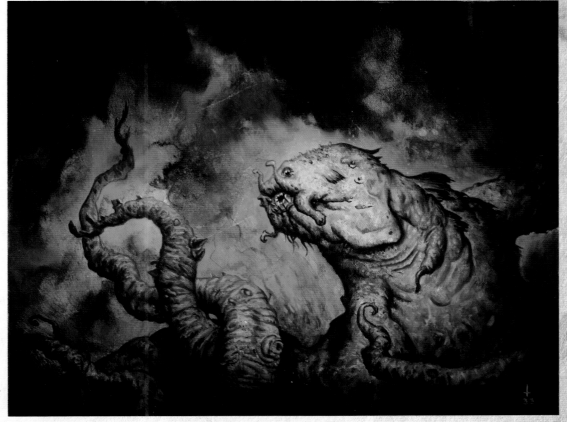

EXAMINING THE FINISHED PRODUCT

To paint the Leviathan, I began with water-based dyes like those used for the zombie. The way the dyes flow together when sprayed with liberal amounts of water is an ideal basis for an underwater background. Once dry, I added further details with oil paint. Remember: Though you can apply oil-based media on top of water-based media (such as watercolors and acrylics), you can't put water-based media on top of oil-based media. The vehicles that the pigments are suspended in have different physical properties and drying times. Though oil paint may seem dry, it is actually dry only on the surface, so any water-based media put on top of it would soon begin to flake off.

The Orobon

The Orobon is as deadly on land as it is in the water. The legend of this creature grew out of the region around the Red Sea during medieval times. The Orobon uses its tail like a giant constrictor to choke the life out of its victims before swallowing them whole. Because of its great size—about thirty feet from head to tail for an average full-grown female—the Orobon is capable of killing and eating an entire caravan of people at one time. In order to digest such a large amount of sustenance, the Orobon must retreat into a state of near hibernation. This is when it is at its most vulnerable.

freedom in obscurity

The Orobon is a rather obscure mythological creature and so of it there exists very few detailed descriptions. This gives you a lot of latitude in your design. For the Orobon, I felt it was important to emphasize its amphibian nature, so I pored over many frog photos for its limb structure and pose. With a solid amphibian base, you are free to create a creature that is fun and interesting that still adheres to the albeit limited historical references. Design the Orobon to your personal specifications. You are, in effect, visually recreating mythology as you see fit.

1 Rough in the Orobon's body using the natural pose of a toad as your guide. At a three-quarters view, two sweeping lines are all you need to capture this basic pose. Place one long convex line (a line following the exterior contour of a circle or oval) that runs from the top of the creature's head and along the centerline of its back to the tip of its tail. Then add a concave line (a line following the interior contour of a circle or oval) that joins the two ends of the convex line to lay in the area where the Orobon's forelimbs will rest and suggest the outside shape of its head.

2 Create a more solid structural drawing of the Orobon by referring back to the toad pose. Make sure the back end of its torso is firmly situated on the ground, flanked by powerful legs that fold in on themselves in three segments. Raise the Orobon's upper torso and head off the ground using its forelimbs. Remember to bend the forelimbs slightly to reinforce the concave line from the initial gesture sketch. Before moving on, mark the placement of the creature's eyes, setting them far back on the sides of its head to emphasize its amphibian nature.

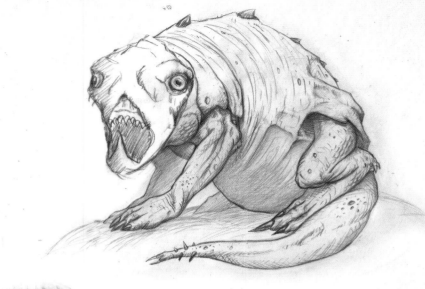

3 Add a blend of details from both tortoises and toads to give the Orobon a unique look. Create a hard, segmented protective covering that resembles a tortoise shell on the creature's back. Make this shell flair out over the Orobon's limbs, leaving a space underneath the shell where the limbs connect with the more vulnerable, fleshy, toadlike torso. Other than the openings for its legs, the shell should not have any discernible edges or gaps. It should blend naturally into the smooth underbelly and wrinkled, bulbous neck area of the Orobon.

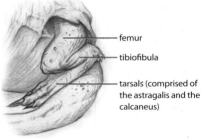

femur

tibiofibula

tarsals (comprised of the astragalis and the calcaneus)

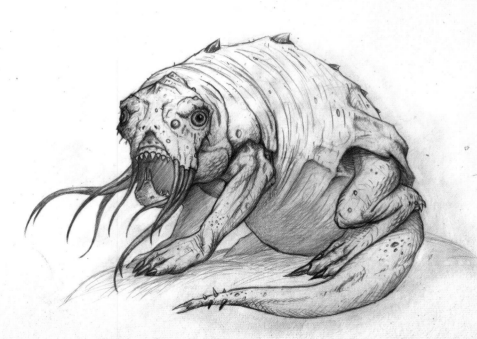

4 Construct the rest of the Orobon's head around its basic shape and the eye placement indicated earlier. Add hard forehead ridges that give way to lumpy wart-ridden skin. Expose the Orobon's upper gums and a row of sharp, pointed teeth to help make it frightening as well as disgusting. To suggest motion, add a series of long, slender tentacles reaching out from the Orobon's upper jaw area. Draw its lower jaw into a pointed central apex that would conceal its upper gums if its mouth were closed. To finish off the face, add two small slits over the Orobon's mouth and between its eyes to indicate nostrils.

The Gaki

Gaki are giant Japanese ogres. Although their hides are reptilian, they often have heads similar to oxen, and their skin is red or green in color. Gaki often have mutated appendages that take the shape of tentacles, pinchers, or enormous clawed hands. Their hunger for human souls is tremendous and often unbearable, sometimes leading them to self-mutilation. When they are able to satiate themselves on the souls of wicked humans who are near death, they express their joy by escorting their conquests to hell to flay them savagely.

dramatic tension in movement

In Japanese tradition, ogres are massive, muscular, and well-armored. A good gesture for such a beast is one captured in the heat of combat. However, the designs in this book are of lone figures, so we must find another way to create the dramatic tension we desire. We can do this by depicting the monster in the moments right before combat. Lots of excitement can be portrayed in the instant before a creature heads into battle. Let's apply this to our Gaki, showing him at that crucial moment before the fight begins, his sword drawn and ready as he charges forward.

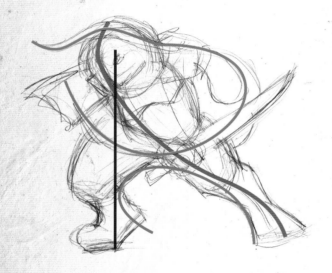

1 Draw your Gaki lunging toward its prey, the weight of his body placed on his right leg as he charges forward. Drop an imaginary line straight down from the Gaki's head to find the proper foot placement. Begin to create your gesture lines around these anchor points and make sure there is a lot of diagonal movement within the piece to portray the beast's momentum.

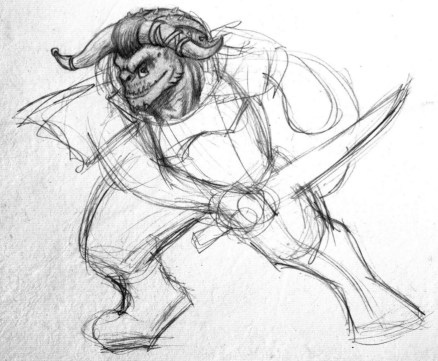

2 Detail the Gaki's head, straying only slightly from convention. Instead of making the head completely oxen, meld it with some reptilian and humanoid aspects. Add the ox horns, but shape the face to resemble that of a human. Make the brow ridges thick and heavy, and shorten the nose dramatically. Add small, round, snake-like eyes, and make the mouth wide, reaching almost to the very end of his thickset jaw. Place sharp teeth, scales, and spikes accordingly.

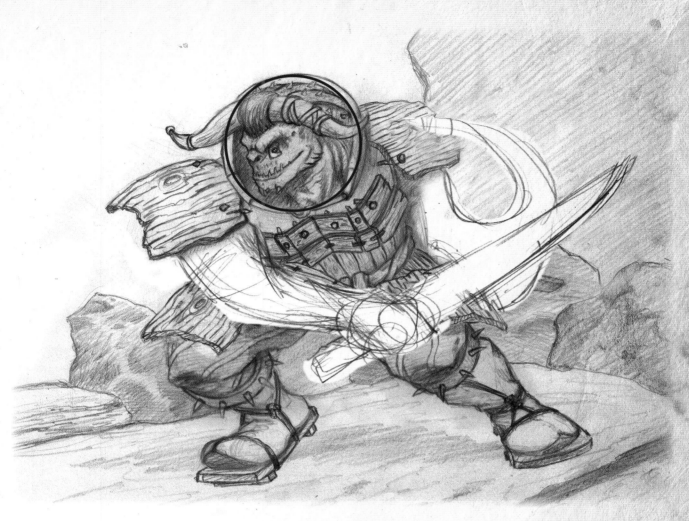

3 Just as you did with its counterpart the oni, base the Gaki's protective gear on traditional samurai armor. Indicate pieces of thick tree bark laced together to create the plates covering his shoulders and torso. Surround the Gaki's head with a giant metal cowl. This adds to his defense and creates a valuable visual cue to draw the viewer's attention. Add some traditional Japanese wooden sandals for an old-fashioned feel.

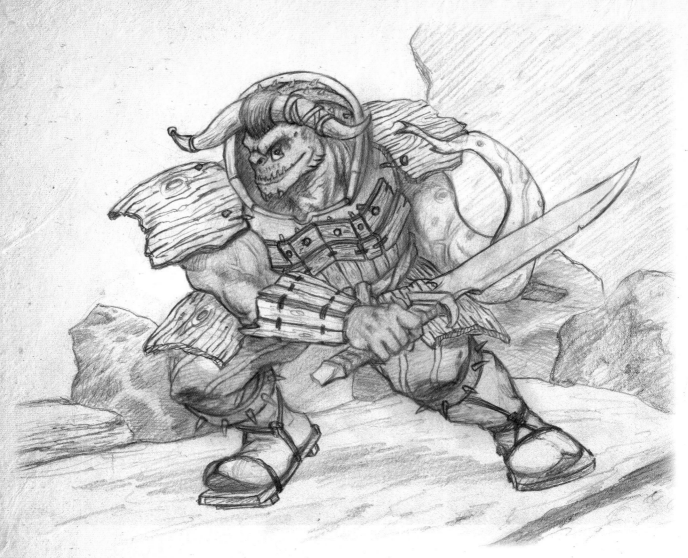

4 Give the Gaki's sword-bearing arm humanoid features, making his musculature look bulky and overpowering. Use bodybuilding magazines as references for drawing massive biceps and triceps. Add some veins and crenellations to his tentacled arm to offset his humanlike arm. Then refine the monster's sword, making it appear large enough that a regular person would be unable to lift it with both hands. The Gaki, of course, can deftly wield it with just one.

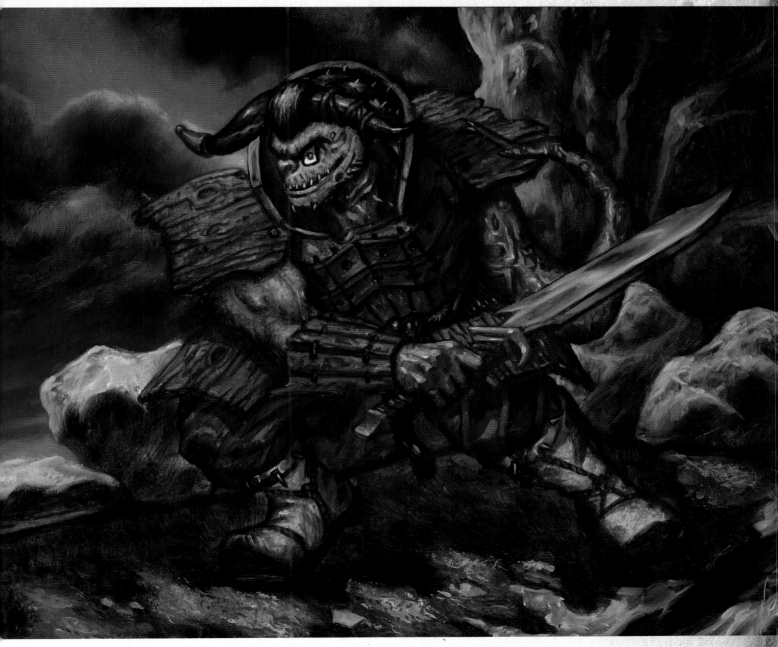

EXAMINING THE FINISHED PRODUCT

For the Gaki, I wanted to employ bold color choices to make the painting really pop, but I also wanted there to be a harmonious balance between the intense colors in both the background and fore-ground. I decided to make the sky a brilliant orange infused with swirls of blue to represent dark cloud masses. I then painted the Gaki a strong green color. In order to tie this together with the colorful background, I made a neutral bridge between the two areas. The boulders surrounding the Gaki provided the perfect vehicle for this scheme. I achieved a smooth transition between the background and foreground by making the boulders gray with some oranges worked into the shadow areas for unification. For the same reason, I also used some neutral browns for the Gaki's armor. Doing so solidi-fies his head as the focal point.

Tiamat

Tiamat, the great cosmic serpent, comes from the ancient cultures of Sumer and Babylon. After the creation of the universe, Tiamat and Absu were the mightiest creatures in existence. Their offspring were horrendous godlike creatures that wrought havoc upon the earth. Although destroyed by the god Marduk, Tiamat's remains were spread throughout the cosmos, and when enough human blood has been spilled in its name, Tiamat will re-form to spread chaos throughout the universe and reclaim the earth for itself.

an evil most ancient

Most representations of Tiamat resemble some form of dragon, which seems too elementary for the greatest of the Ancient Ones. Rather than stick to this simplistic convention, let's make our Tiamat primordial and asymmetrical in design. Tiamat should be a chaotic assemblage of limbs and tentacles. This will work well thematically, as Tiamat is the ultimate symbol of chaos in the universe.

1 Block in the basic form of your Tiamat. Let your gesture lines sweep, cross, and flow in and out of the picture plane. Don't limit yourself to appendages that are uniform in size or even type. Suggest the outline of a very large reptilian arm on the creature's right-hand side. To contrast the grand scale of this arm, lightly indicate a small oval-shaped head.

2 Using the creature's head as a hub, or starting point, add a series of strategically placed diagonal lines to indicate insectlike limbs. These lines serve to move the viewer's eye through the picture and back again to the focal point, Tiamat's head. Make the weight of this bizarre mutation's upper torso move backward in space while keeping it upright. Add support to its small arm by placing an oddly shaped, moss-covered rock formation beneath it.

3 Create a wide variety of textures and patterns on each of the Tiamat's limbs and appendages. For the large reptilian arm, create a unique network of scales that resemble a pattern of diamond-shaped protrusions rising slightly off its light, slimy skin. Begin by drawing a series of randomly placed diamond shapes on the arm. Make the shapes largest in the center of the arm and hand, decreasing in size as they radiate towards the claws. Once you have the shapes drawn, shade them with your pencil, leaving a small highlight in the upper right corner of each one to indicate the direction of the main light source. Shade the head and the connected appendages fairly darkly. Go back in with your eraser to pick out the highlights, and use a softer lead to strengthen the darks.

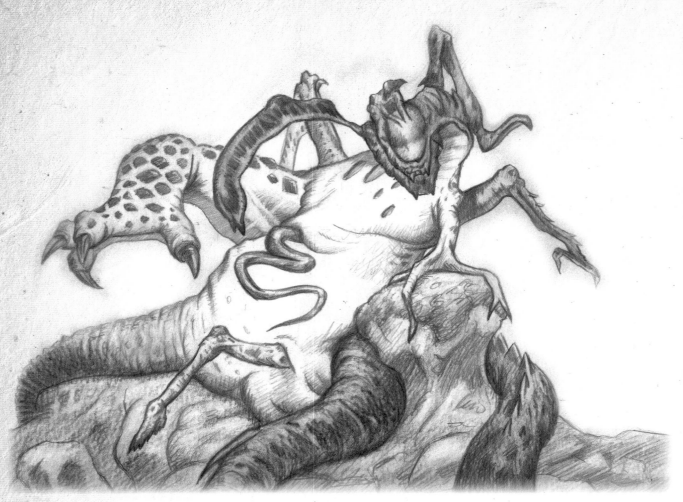

4 Continue the expression of texture throughout the entire creature. Give each of the three large tentacles at its base a unique texture. Try to capture the skin of an earthworm on one, a sea eel on another, and a spotted lizard or toad on the third. This not only gives the Tiamat a visually rich blend of textures, but also suggests that the beast is equally dangerous on land and in the water. Add smaller snake and insect appendages on its body at strategic points to emphasize secondary gesture lines and create overlap with other features. Also, add some detail to the rocks. Apply the theory of curves and straights, making some rocks smooth and rounded and others sharp and jagged. Variety is key when drawing anything organic, so be sure to vary the size and shapes of the individual rocks.

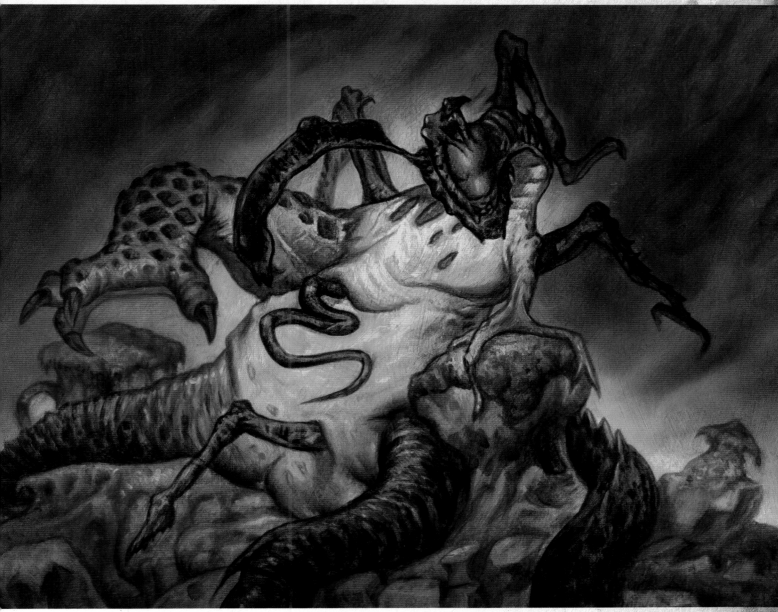

EXAMINING THE FINISHED PRODUCT

Looking at the finished Tiamat painting, many would claim that my use of color is as chaotic as the creature itself. Though I do enjoy riding the fine line between chaos and order in my paintings, one thing that helps me keep this piece from getting out of control is its balance of warm and cool colors. Warm colors are the colors of fire: reds, yellows, and oranges. Cool colors are the colors of water: blues, greens and violets. In this particular painting, an intense yellow-orange light source is visible behind the hulking beast. However, I avoided letting warms take over the piece by placing cool colors directly next to warm colors of the same value. Using color like this brings vibrant life to something that might otherwise seem drab.

The Basilisk

The Basilisk is the king of serpents, a mighty crown of horns upon its head. Any contact with a basilisk whatsoever brings instant death: its glare disintegrates bone; its spit boils flesh; its breath brings decay to all things living; and any area it inhabits quickly transforms into barren desert.

sultan of serpents

Throughout history the Basilisk has changed from a simple serpent to a gigantic reptilian beast with eight legs. One thing that has remained constant, though, is that the Basilisk's throat is said to never touch the ground. In keeping with this part of the mythology, we will give our basilisk a long serpentine body that is raised off the terrain by its limbs. We'll also make our creature unique by incorporating ferocious features to its head and shoulder region. Giving this mighty beast a traditional snake or lizardlike head would be too mundane; our basilisk truly needs to live up to his title as king of serpents.

1 Move your pencil around the page as if your arm were the wriggling tail of a snake, letting your gesture lines flow openly and freely. Develop the core of the basilisk and its limbs from these marks. At this point, roughly indicate a shape upon which the basilisk is contorting. Later, develop this into a rocky structure or another base of your choosing.

2 Develop the head and shoulder region of the basilisk, incorporating deadly features from a multitude of other animals. Make its snout and forehead like that of a pit viper and add a crown of horns along its brow ridge. Draw in spiderlike eyes and a row of thick, pointed fangs dominated by one huge central fang on its upper jaw. Although such features are unnatural to reptiles, they will work perfectly for emphasizing the ferocity of our creature. Add random slimy protuberances and a giant forked tongue to finish off the head. Introduce elements of the crocodilians, the only remaining descendants of a group of dinosaurs known as Archosaurs, to the neck and shoulder regions. Make the skin on the shoulders rough and thick, flaring out over the arms like shoulder pads on a bloodthirsty gladiator. Add layer upon layer of sharp horny growths around this area. Our basilisk has now become more than a mere serpent—he has become a reptilian nightmare.

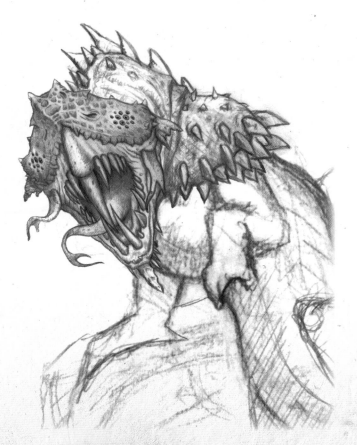

3 Keep the midsection of the basilisk somewhat smooth. This will give the viewer's eye a place to rest as it moves over the great beast. As you work your way towards the tail of the basilisk, slowly build up a skin texture like that of a crocodile, tying the creature's lower body to its shoulders. To achieve this texture, begin with simple parallel bands that wrap around the creature's girth. As you move back, draw lines running diagonal to these bands on the tail's top half.

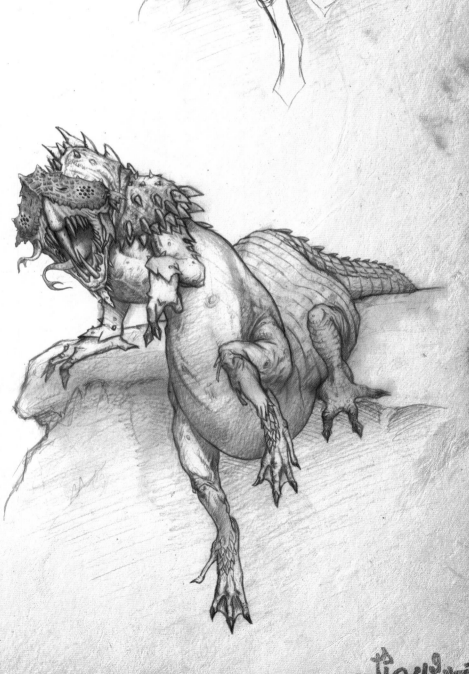

4 Treat the limbs of the basilisk in a similar fashion to the head and shoulders. Develop unique limb and foot structures by looking at reference photos of different toads and lizards. Don't fall into the trap of making every reptilian-based creature you draw have dragonlike limbs: There is nothing more diverse than the natural world that surrounds us, and this should be reflected in your compositions.

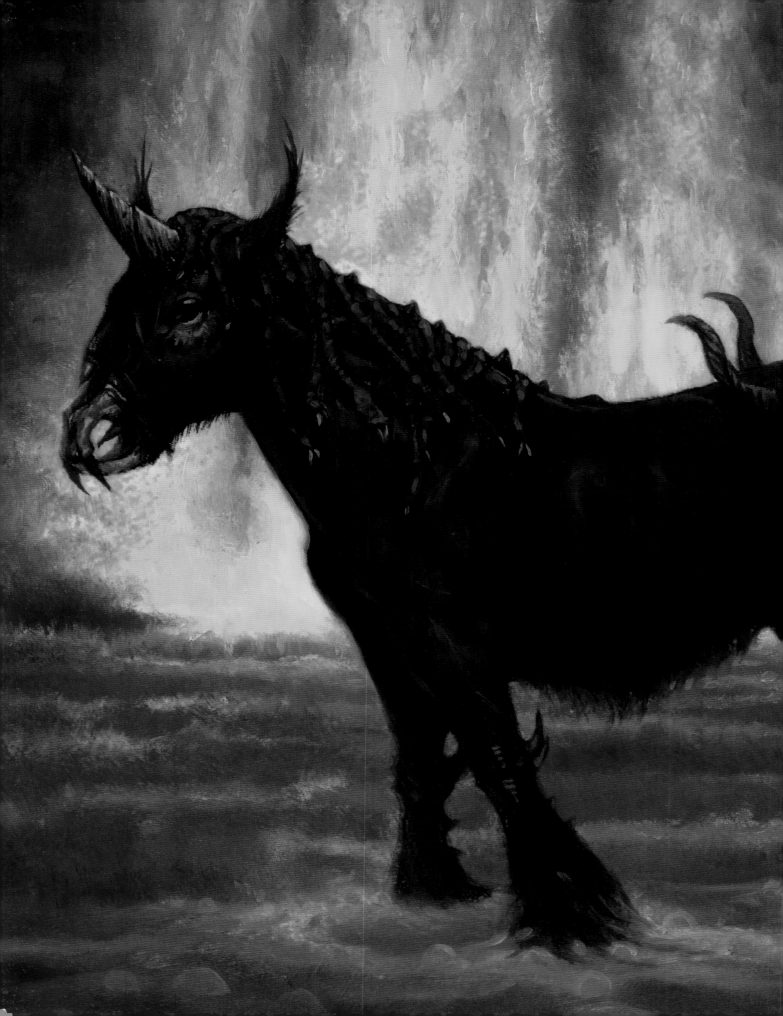

QUADRUPEDS AND MORE

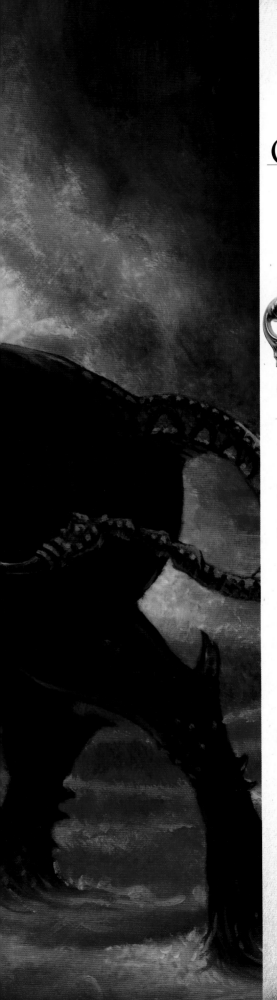

Our everyday surroundings provide us with a rich basis of inspiration for drawings. Quadrupeds, or animals that move on four legs, likely cross your path regularly. Chances are, you encounter creatures with even more legs, like spiders, centipedes, and numerous other insects, from time to time as well. These everyday animals and insects can serve as models when designing fearsome monsters. There is no limit to the ways you can combine aspects of various animals in your own creations. Many creatures from mythology are just that—a combination of animal parts. The classical centaur, for example, is simply a human torso on top of a horse's body. I use this same principle when creating many of the creatures I draw. Don't be afraid to experiment. Combine aspects of three, four, or even ten different animals to come up with your own unique hell beast. As long as you abide by the basic principles of drawing and add your own artistic flair, you'll come up with something interesting every time.

The Giant Rat

The average-size rat is enough to make most people run for cover. These scavengers wander the streets at night, their beady eyes and hair-raising squeals penetrating the darkness as they search for carnivorous delights. If these little vermin were responsible for carrying the Black Death, decimating the population of Europe during the middle ages, just imagine what a rat of enormous proportions could do.

a monstrous menace

Since generic rats spend most of their time hidden from the human eye, this monster should do the exact opposite. As such, let's draw our rat out in the open for all to see, baring its enormous fangs and forcing out a shrill death cry that causes humanity to cower in fear. Likewise, let's add to the rat's grotesqueness by making it as ugly as possible. For example, leaving the creature hairless from the neck down and adding hornlike growths to its skin will make our rat terrifying to look at.

1 Create a brief series of alternating concave and convex lines to capture the gesture of the rat. Suggest a strong arch in the creature's back, indicating that its lungs are filled with air to power its terrible shriek. Add a large set of horns, and rough in a sweeping tail to round out the composition. At this point, our rat is a very simple yet strong shape.

2 Begin constructing the rat's limbs, paying close attention to the negative shapes that emerge. With a compact pose such as this, negative shapes are very important to creating visual interest within the form. Indicate a light source that is coming from above and to the right of the creature, and block in a large shadow area that encompasses the entire underside of the rat and its rear legs. Look to photos of rats to craft the head, exaggerating areas that make the rat look creepy. Enlarge its two front teeth until they become fangs, and make its eyes beady and completely black. Then lengthen the hair along its jawline to make it look wild and savage, and add a second whiplike tail to suggest mutation.

74

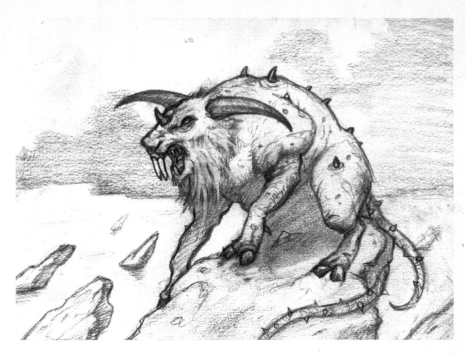

3 Make the rat hairless from the neck down. Toughen the exposed hide by drawing in deep grooves and indentations. Add small horny growths and barbs all over its body and tails. Refine the limbs by incorporating a series of complementary straight and curvy lines. The overall gesture of the lower side of the limbs should be straight to indicate support, while the upper parts should be curved to suggest impending action. This technique is important in creating life within your drawing, as well as keeping it from turning into a series of bulbous muscles that appear to have no skeletal structure. Finally, replace the normal tiny rat claws with heavy toes based on those of a rhinoceros, giving the beast the size and weight we are looking for.

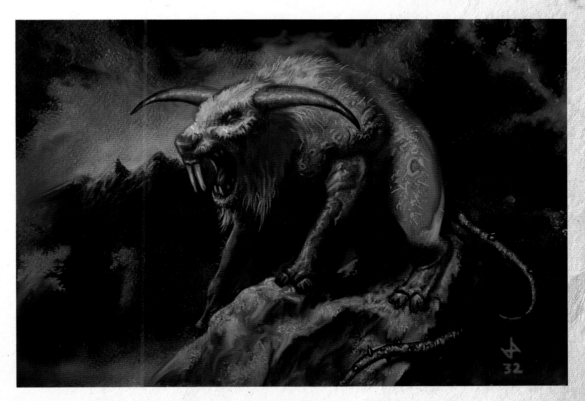

Examining the Finished Product

In order to create a stark contrast between the creature and his surrounding environment, I made the rat white and used a broad range of vibrant colors in the background. I began by using water-based dyes to suggest the cloud and mountain formations. I then went back in to soften edges, brighten highlights, and darken shadows. To finish, I added white to the rat, and mixed background colors into the shadow areas of its form to help unite it with the background.

The Steed of Abigor

Abigor, a demon warlord of hell, led his sixty legions of devils into battle astride this diabolical steed. A gift from Beelzebub, and reanimated from the skeletal remains of a horse of Eden, the Steed of Abigor has strode through many battles unscathed due to the sinister power it draws from its master. With heavy claws in lieu of hooves, it has torn the flesh and scared the wings of scores of angelic adversaries.

gracefully sinister

The anatomy of a horse is very unique; therefore, reference materials should be gathered before attempting to render it. Look to numerous photographic books exclusively dedicated to horses for assistance.

Once you have a grasp on the anatomy of the horse, you can make several significant changes to create a more sinister feel. For instance, a normal horse has seventeen thoracic vertebrae; by merging these into much larger, jagged bones, our horse becomes mutated and baneful. We can also alter the shape of the scapula (shoulder blade) and humerus (upper leg bone) and add spikes where the bones change directions. Continuing this kind of transformation throughout the animal helps us create a beast that not only appears maniacal, but actually looks like it could move in the same manner as a real horse.

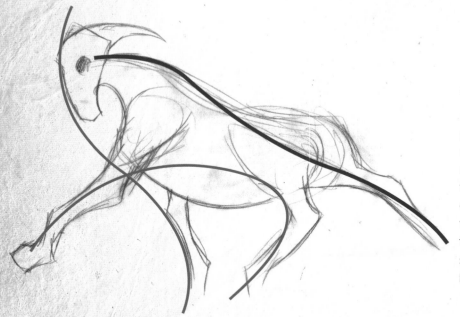

1 The great thing about capturing a horse gesture is that its anatomy grants you a natural and long visual cue that runs from its head along its spine and through its tail. Even though the Steed of Abigor will have no flesh, create the gesture drawing as you would for a normal horse. Start with fluid lines, capturing the sweep of the spine and the movement of the legs. Lightly indicate the rib cage and pelvis.

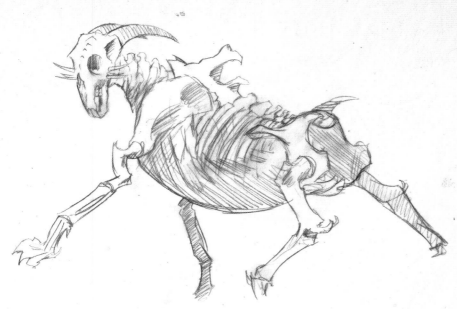

2 With the basic shapes in place, begin to render the individual bones and muscle groups. *An Atlas of Animal Anatomy for Artists* by W. Ellenberger and Frances A. Davis is one of the best books available on animal anatomy and has detailed drawings of the horse from many different angles. Continue to keep your shapes basic at this point, and concentrate on making all of the individual parts of the horse fit together properly before detailing anything. Within those parameters, though, supplement certain bone structures with bony spikes and sharp ridges. Since the steed doesn't wear armor, you want the anatomy to look like it would be lethal in combat.

3 Add detail to the bones, concentrating specifically on making the steed's head and shoulder girdle look vicious and nasty. Add a series of long slender horns above its jaw, and add a bony ridge along its skull.

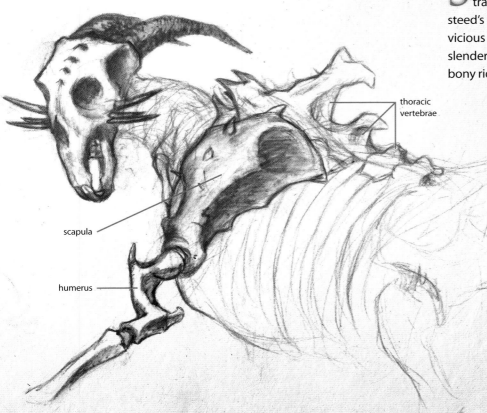

thoracic vertebrae

scapula

humerus

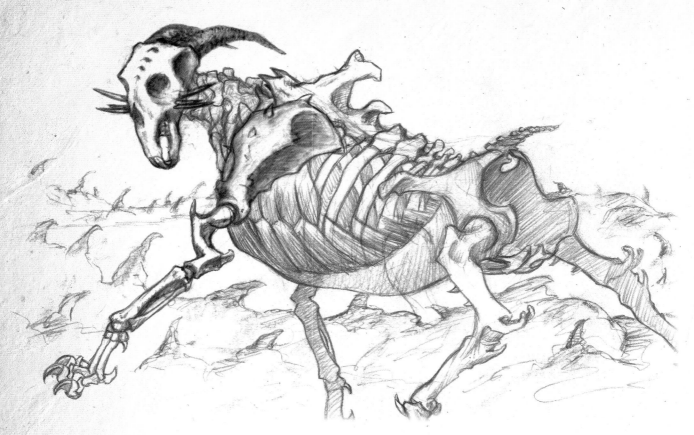

4 Finish this hell beast, continuing the mutation of referenced anatomy that you learned about in the previous sections. Let your imagination be your guide here. If you don't want your horse to have hooves, perhaps give it bony clawed feet. Let muscle remain where it ties into the ribs. This will break up the monotony that would occur if the steed were entirely comprised of bone. Expand and contort the bony ridges like those in the pelvis and legs of the horse.

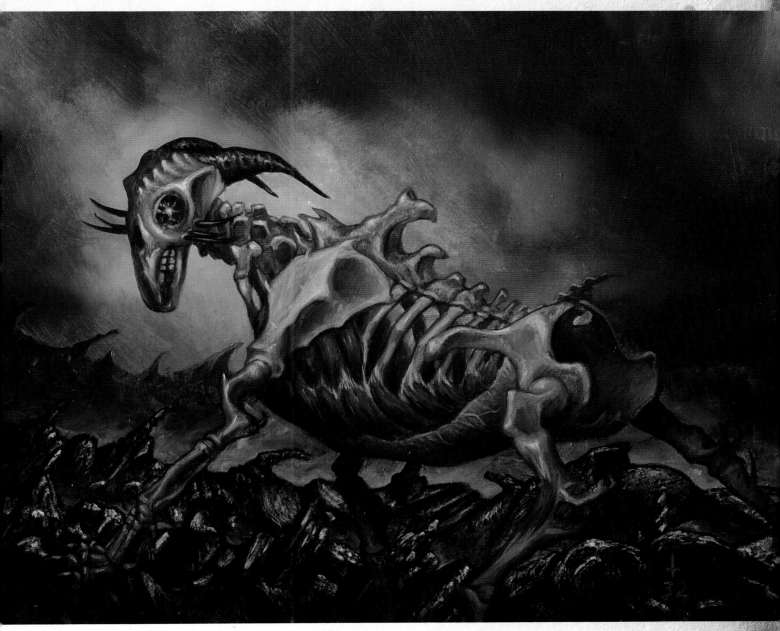

EXAMINING THE FINISHED PRODUCT

Since the Steed of Abigor is a minion of hell, I wanted to put him in a hellish landscape, but I also wanted to avoid the traditional color scheme of reds and oranges. I made the steed a standard bone color and worked that same color into the background as an ambient light source penetrating through layers of black and gray smoke. I painted the brightest area of this light source around the steed's head to prevent it from getting lost in the background. To keep the piece from becoming a simple black and ochre composition, I added a shocking blue-green mist to the background. This not only livened up the colors, but also added an eerie element that enhanced the overall mood.

The Were-Spider

In an attempt to achieve control over the actions of mankind, a dark sorceress participates in sinister rituals that transform her into a being that is half human and half spider. This creature is known as the were-spider. Along with the advantages the transformation grants, i.e., powerful mind control and increased physical abilities, unfortunate side effects can't be avoided: a newfound appetite for human blood and a longing for solitary existence in the dark corners of the world.

a creeping beauty

A very important aspect of drawing our were-spider is to make her face human and feminine. To achieve a realistic composition, it is essential to use a female model. It's also important to construct the face with as few lines as possible, as extraneous lines take on the appearance of wrinkles, aging your subject.

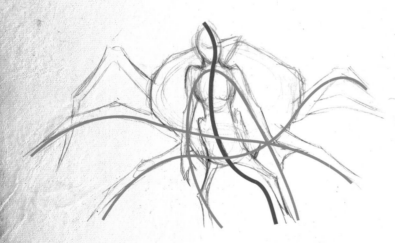

1 Block in the four basic shapes of your spider: head, thorax, abdomen, and legs. Attach the head to the roughly egg-shaped thorax. Likewise, attach the thorax to the similarly shaped yet larger abdomen at the rear of the spider. Insert one pair of legs into the thorax and attach the remaining three pairs to the abdomen.

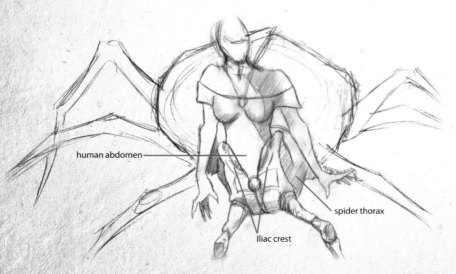

human abdomen

spider thorax

Iliac crest

2 Meld the spider anatomy with a human torso and arms, making the design unique yet functional. Exaggerate and elongate the iliac crest of the female pelvis, inserting a pair of legs at the point where human legs would normally appear. Segment the surface of the pelvis area like that of an insect and connect it to the abdomen of the spider.

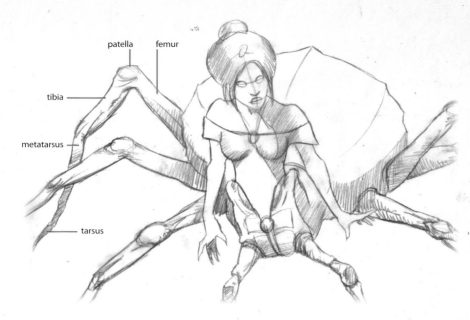

patella
femur
tibia
metatarsus
tarsus

3 Refine the abdomen of the were-spider, drawing a slightly flattened oval with several rows of spiked protrusions to help indicate its shape and volume. Detail the legs, making them thin and tapered. Display five of the seven segments that make up a spider's leg, excluding only the two small segments obscured from this point of view. Add claws to the ends of the tarsus to make the legs more realistic.

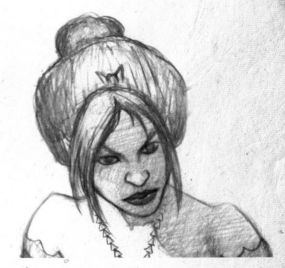

working from reference

Christine will serve as the model for the face of our were-spider. She has both beauty and mystery, making her the perfect subject. Remember, when using reference photos you don't have to render every detail as it appears. Rather, use the photo for inspiration and as a base for simple structures.

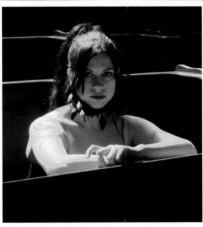

4 Using the reference photo of our model, create a face for the spider that is beautiful yet malevolent. First draw the basic shape of the face and hair, then add features and details. Make her eyes large and almond-shaped, with thin, shapely eyebrows that angle sharply toward the nose. Add the nose by drawing a single line that defines the lower edge of the nostrils and tip. Avoid adding any extraneous lines in this area, as they will add years to her appearance and take away from her elegant beauty. Finally, draw a thick, full set of lips. Since the upper lip recedes into the skull from top to bottom, it should fall into shadow.

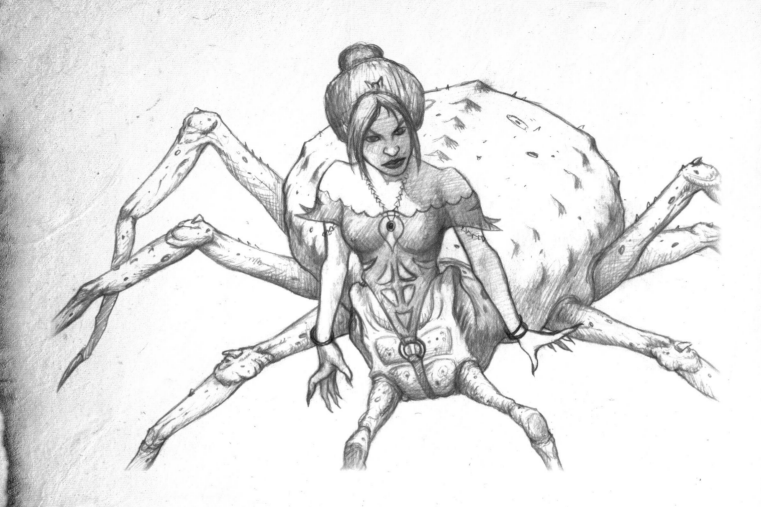

5 Fine-tune some of the details, such as textures and costume. Try to mimic some of the physical aspects of the spider in her attire. For example, add pointed edges to the neckline and arm areas, and cut out segmented patterns around her stomach to play off of the segmented structure of her body. Finally, add sharp coarse hairs, small protrusions, and pits along the spider parts of her body to contrast with her sleek and beautiful upper half.

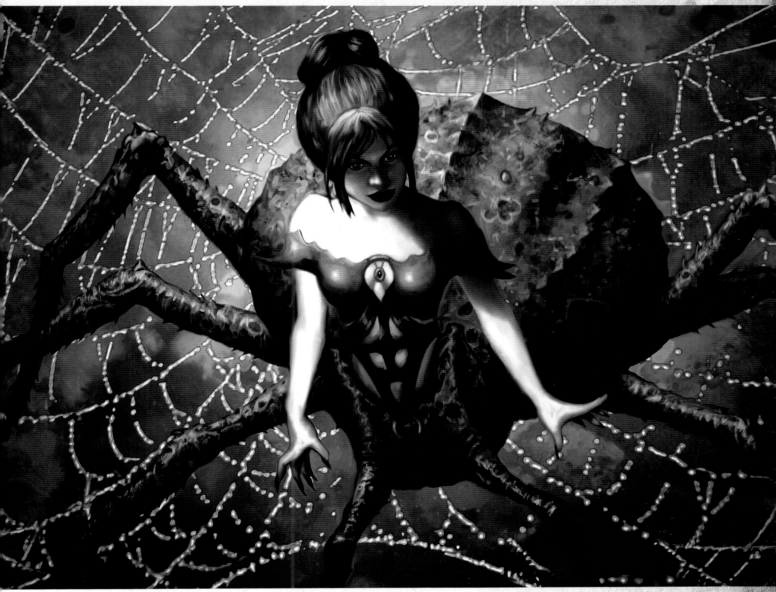

EXAMINING THE FINISHED PRODUCT

John Singer Sargent's painting *Madame X* (1883–84) has always had a tremendous impact on me. I wanted to incorporate some of the elements from this masterpiece—such as the delicate pale flesh, the striking black garments, and the gesture of the madame's left hand—into my were-spider painting. I also wanted the background to act as an abstract graphic element rather than a strict representation of a cave lair. Since the were-spider is a cold and manipulative beauty, I felt that a predominantly blue background worked well. I dropped in some warm purples and lightened the background around the spider's thorax to bring it forward in space. I then placed the spider web behind her figure using Photoshop.

The Hellhound

Humans often report seeing hellhounds in their night-mares. This is because, as a tool of Satan, the hellhound can sniff out those capable of great evil by going into their dreams. The hellhound is often the initial demonic contact a person will have before setting out on a path that ends with the signing of a blood oath with Lucifer.

hell's furious canine

To portray the fearsome aggressiveness of the hellhound, a forceful action pose is required. Try to capture the beast from a worm's eye point of view, lunging through the air with its mouth wide open in rage. Examine books on attack dogs for good reference photos. Remember, though: If we made the hellhound look exactly like a pit bull or a Doberman, it would be too relatable to an every-day animal and would lose some of its impact. Therefore, adding traits from a variety of canines, as well as elements purely from your imagination, is the best path to success.

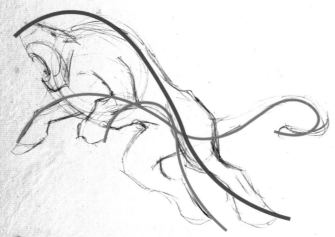

1 Block in the basic shape of the hellhound, capturing the gesture and anatomy of a dog leaping and contort-ing with great fury. Visually tie the creature together and suggest a sense of forward motion with a smoothly curved gesture line originating at the hound's nose and terminating at its hind paw.

2 Place the upper and lower jaw of the hellhound's shrieking head along the secondary gesture line. This leaves you with a solid triangular shape for the whole of the beast's head. Keep in mind that since the camera is looking up at the hound's head, the viewer will be looking into the underside of the snout, and the creature's eye will appear high up on its head. Make its features sharp and pointed. Huge fangs, horns, ears, chin scruff, a forked tongue, and small horned growths along its jawline should all end in sharp points, making the hound's head mimic a mace.

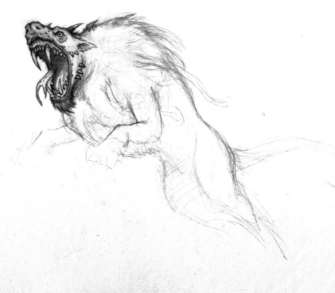

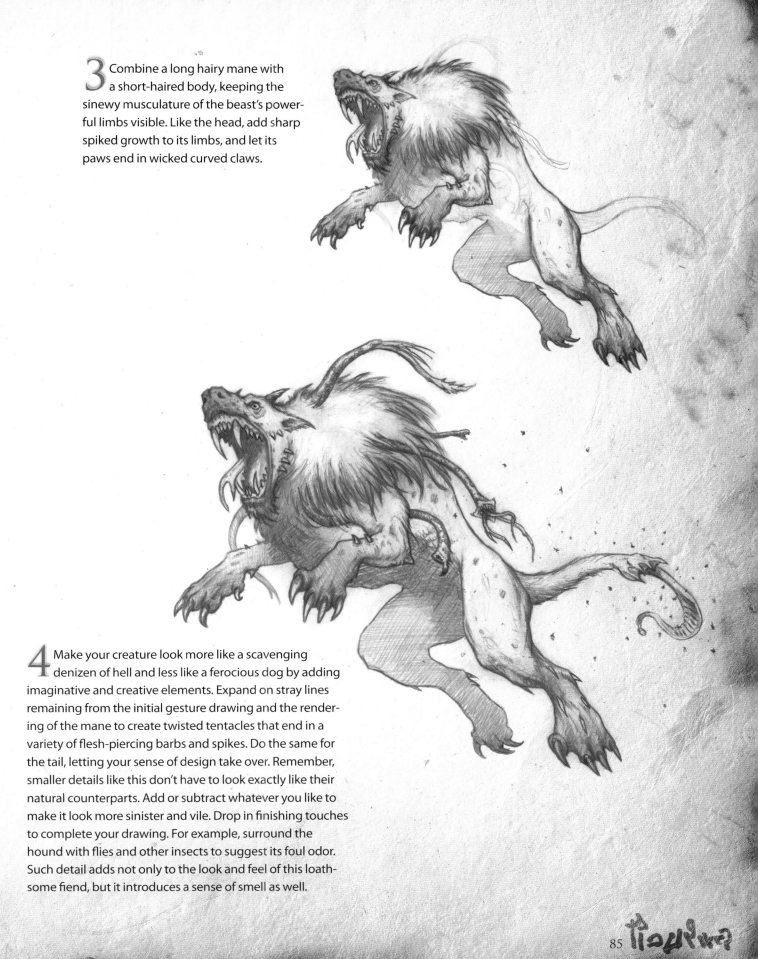

3 Combine a long hairy mane with a short-haired body, keeping the sinewy musculature of the beast's powerful limbs visible. Like the head, add sharp spiked growth to its limbs, and let its paws end in wicked curved claws.

4 Make your creature look more like a scavenging denizen of hell and less like a ferocious dog by adding imaginative and creative elements. Expand on stray lines remaining from the initial gesture drawing and the rendering of the mane to create twisted tentacles that end in a variety of flesh-piercing barbs and spikes. Do the same for the tail, letting your sense of design take over. Remember, smaller details like this don't have to look exactly like their natural counterparts. Add or subtract whatever you like to make it look more sinister and vile. Drop in finishing touches to complete your drawing. For example, surround the hound with flies and other insects to suggest its foul odor. Such detail adds not only to the look and feel of this loathsome fiend, but it introduces a sense of smell as well.

The Behemoth

The Behemoth has its roots in Judeo-Christian mythology. It is a massive creature, larger than any elephant, whose every footfall causes the earth to tremble. It was imbued by the devil with great destructive powers, and the desire to lead the masses of humanity into selfish acts of greed and gluttony. A great number of cults sworn to do the bidding of the Behemoth arose to counter the spread of Christianity throughout the world. These followers were nearly impossible to identify, as they possessed a great ability to deceive and manipulate in the name of the Behemoth.

environmental lighting

Environmental lighting is an effective tool to direct the viewer's eye where you want it to go. For example, if a creature is standing outside on a sunny day, the lighting is very uniform and lacks the punch that you want in a fantasy piece. With environmental lighting, you can add cast shadows from nearby objects (e.g., trees or covering clouds) onto the central figure of your drawing, concentrating light in the areas on which you'd like the viewer to focus. Let's keep this in mind when drawing our Behemoth, making its head and left forelimb strong focal points.

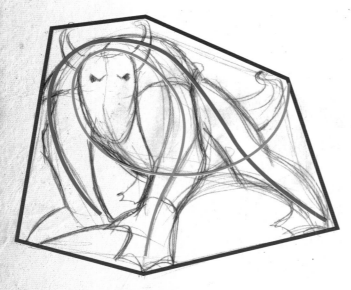

1 Build the Behemoth's pose upon a solid base, hinting at its massive size and emphasizing the fact that it is a creature that moves on all fours. However, be careful not to make the gesture completely devoid of motion. Plant three of its feet firmly on the ground, but make the left forelimb reach out toward the viewer to suggest that the creature is moving forward.

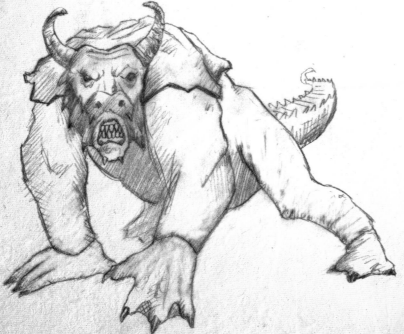

2 Incorporate elements of the largest species of mammals and reptiles to show the creature's size. Add a plate-like hide, derived from a rhinoceros, and various head features including horns and a snout that resemble those of a bison. Draw a heavy tail that counterbalances the incredible mass of the upper torso and functions as an offensive weapon.

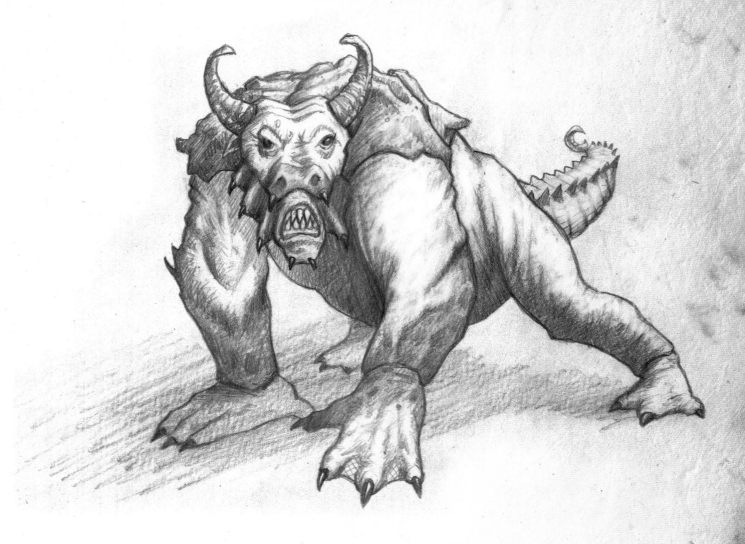

3 Using the environmental lighting concept, create cast shadows on the majority of the creature's forelimbs, allowing just the end of its gigantic clawed paw to break back into daylight. This lighting scenario also means that the underside of the Behemoth falls in the shadows, allowing its head to emerge from the darkness as a central point of focus. Through a creative use of light and shadow, we have set up a hierarchy of points of interest that is effective without looking contrived.

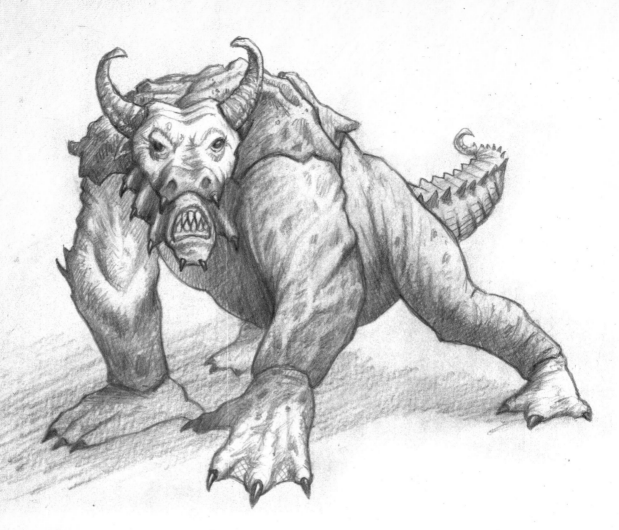

4 Add texture to the surface of the Behemoth's hide. Use a variety of pencil strokes, from rapid back-and-forth movements with the side of your lead to more precise hatchmarks, creating areas of light and shadow. Fill its hide with ridges and wrinkles, allowing some of the areas on its head to remain smooth to create interesting contrasts.

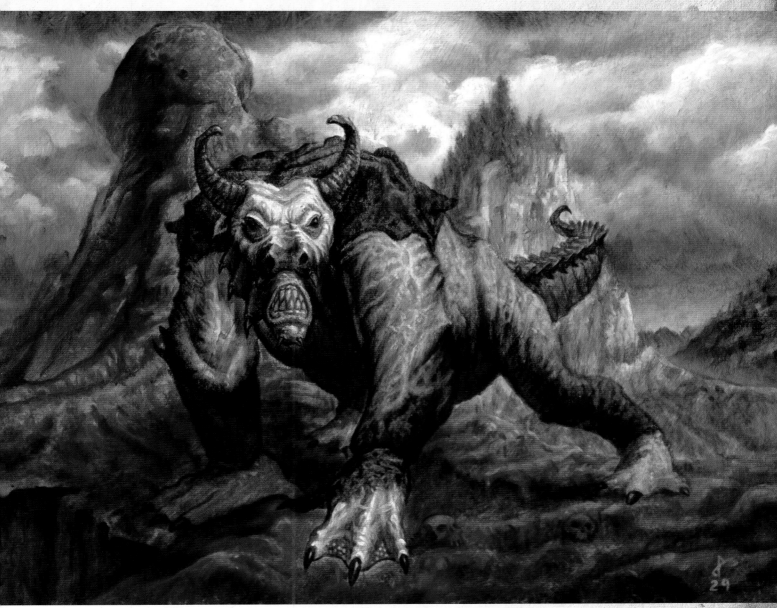

EXAMINING THE FINISHED PRODUCT

I set up a unique challenge for myself in this piece by deciding to paint the Behemoth the same color as the sky. However, by surrounding the Behemoth with fairly uniform reddish rock formations, I created an area for the eye to take a break from all the blues. A mountain set further back, that's lit by intense sunlight and casts blue shadows, served the dual purpose of bridging the gap between foreground and background and keeping the monster from getting lost in the clouds.

The Necrosect

The Necrosect is nothing less than every human's worst nightmare—an insect roughly the size of a large dog that fears nothing but fire. A Necrosect's chitinous hide is nearly impenetrable. Its many legs are laden with rows of skin-piercing barbs. These barbs, combined with the Necrosect's sticky claws and pinchers, help the creature trap its victims and slash them to ribbons. Its eyes are perfectly suited for enhanced night vision, and its speed and agility are unmatched for a creature of its size.

tough as nails

It can be difficult to come up with a fluid and interesting gesture for an insect-based monster, as insects are spineless creatures that resemble a conglomeration of segmented shapes. Therefore, let's focus on an overall shape first and break it down from there. When trying to capture a shape for a creature, it is good to relate to a realistic object. For this hard-shelled killing machine, we'll start with a diamond-shaped base and build interest with the addition of details.

1 Create the basic outline of the Necrosect using a diamond-shaped gesture line as your starting point. Tilt the diamond shape on its horizontal axis about 15 degrees to create more visual interest.

2 Draw a mass of spiny limbs and layers of overlapping, thick-shelled exoskeleton segments that act as armor. Now that the overall structure is in place, suggest an arch-like gesture line with the beast's head at the top. Let all of the Necrosect's limbs and protective parts flow off each side of this arch pattern like the streams of a waterfall. Allow the center to recede into darkness.

3 Fill in the remainder of the original diamond shape with a large vented hood that wraps around the Necrosect's head. The head itself should mimic the diamond shape for design continuity. Maintain a balance between smooth rounded edges and sharp pointed ones. Concentrate a large amount of the sharp pointed edges around its head to emphasize it as the focal point. Create some uniquely shaped antennae that overlap and break the edge of the hood area. This will help bring the Necrosect's head forward.

4 Add numerous legs to this night crawler to set it apart from most ordinary insects. Have the legs emerge from the darkness of the underbelly in a variety of shapes and sizes. Make some strictly insect-like, while giving others birdlike features.

CHAPTER FIVE

WINGED BEASTS

I n my estimation, there aren't enough winged animals who swoop down and carry men off to be their dinner. That's where fantasy artists comes in: It is our job to put the ferocity back into winged creatures. Leathery wings, razor-sharp beaks, talons that can flay a man alive—that's what the world needs more of. And don't forget the humanoid creatures with wings, either. Who will speak for them? You, that's who! Put your pencil to paper and remind viewers of the majestic demon lord who strides through his lair of pain with tattered wings, doling out suffering to his victims. Breathe new life into long lost winged monstrosities in honor of the great dragon, who similarly breathed fire into the human wretches who forgot to honor it.

The Dragon

Dragons exist in almost every mythology. A wealth of visual imagery has been created to coincide with the abundance of dragon lore written throughout history, with depictions of dragons dating as far back as the fourth century B.C. Many artists of times past, such as Albrecht Durer, Henri Fuseli, and Gustave Moreau, used dragons of different varieties in their narrative masterpieces. In today's fantasy market, you need look no further than the works of Jeff Easley and Todd Lockwood to see the dragon taken to the pinnacle of design and color. All of these sources give you a great body of work to draw from when creating your own dragon. Just keep one rule in mind: Since this book is about drawing beasts that are evil and loathsome, set aside the images of wise, kind, and cute dragons and focus on designing a beast bent on destruction.

variety is the spice of destruction

There are quite a few distinct differences between dragons of Western and Eastern tradition. The Western dragon, which is popular in most fantasy fiction, has an elongated reptilian body with huge batlike wings, a crested brow ridge, and spiked dorsal fins extend down its spine to its tail. Oriental dragons, on the other hand, tend to have heads with beards and whiskers, as well as long serpentine bodies without wings. Because we want to draw a ferocious creature in flight, the dragon in this demonstration will stick primarily to Western conventions.

1 Rough in the gesture lines of the dragon, including the creature's wings. Because the wings of any dragon in flight are so large, they risk looking unbalanced or abnormal if they are added on as an afterthought. With this in mind, be sure to incorporate the dragon's wings into your initial gesture drawing.

Place a simple triangular shape where the dragon's head will be. Refrain from adding any details to the head at this point, concentrating instead on perfecting the rest of the dragon's anatomy. Make the dragon's torso contort in rage as it swoops forward. To convey this action, use a series of intertwined straight and curvy lines. Draw a straight diagonal line that serves as the main gesture line, extending from the tip of the dragon's tail (which will be in the lower left segment of your drawing) all the way through its wings (which will extend off the page in the upper right corner). Make the curved part of the gesture line come through the dragon's neck and torso as it bends forward to attack its prey. Suggest the spiked dorsal fins that stretch down the creature's spine all the way down its tail before moving to the next step.

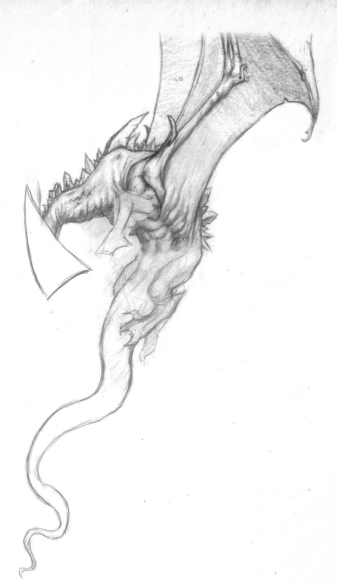

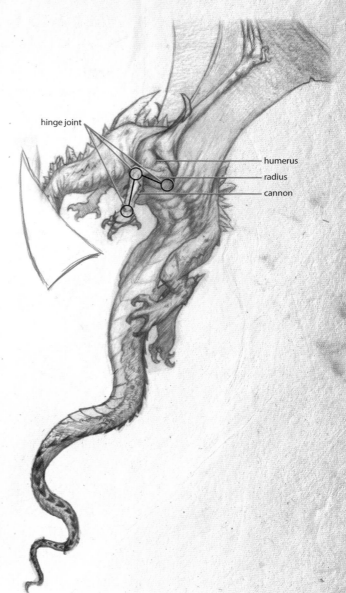

hinge joint

humerus
radius
cannon

2 Make the primary and secondary gesture lines intersect at the point where the dragon's shoulder ties into the structure that will support its wing. Fantasy and functionality must coexist here. A creature that weighs three tons will not fly on wings that attach to its body like a hummingbird's. Create a large muscular structure that connects to the underlying forms of the rib cage and scapula, yet allows for unencumbered movement of both the wings and the arms. Make sure the entire wing connects to the dragon itself, not just the area near its shoulder. To do this, tie the wing into the side of the dragon as you would when drawing a bat. Since no creature in nature near this size can fly, you are on your own to some extent in creating the anatomy of this region. Don't be nervous. You can find a great deal of information that will help you figure out a logical solution simply by studying the shoulders and rib cages of large mammals such as horses.

3 Create limbs that are powerful enough to hold up the dragon's tremendous weight yet agile enough to snatch smaller prey. Base your dragon's limbs on a combination of horse and lizard anatomies, the end result being incredibly powerful yet incredibly flexible appendages. Like a horse, the dragon's forward limbs have three different bone sections. Each joint is a hinge joint bending in opposition to the one above it. Although the forelimbs are equestrian in structure, make them reptilian in texture. Keep the dragon's hind legs reptile-like with additional bony support in its feet and toes.

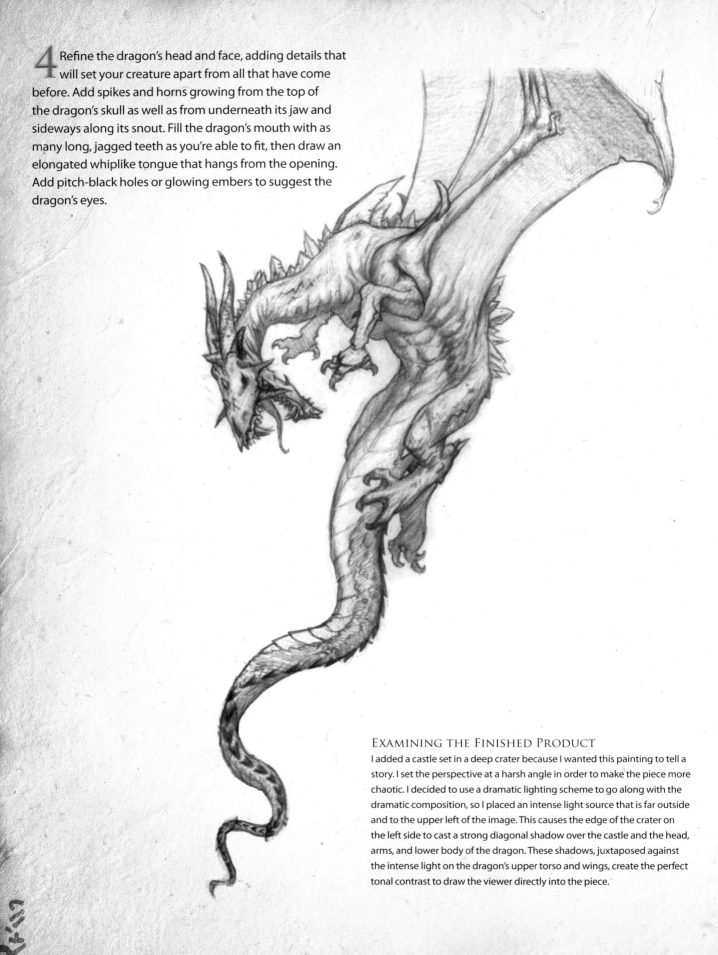

4 Refine the dragon's head and face, adding details that will set your creature apart from all that have come before. Add spikes and horns growing from the top of the dragon's skull as well as from underneath its jaw and sideways along its snout. Fill the dragon's mouth with as many long, jagged teeth as you're able to fit, then draw an elongated whiplike tongue that hangs from the opening. Add pitch-black holes or glowing embers to suggest the dragon's eyes.

EXAMINING THE FINISHED PRODUCT

I added a castle set in a deep crater because I wanted this painting to tell a story. I set the perspective at a harsh angle in order to make the piece more chaotic. I decided to use a dramatic lighting scheme to go along with the dramatic composition, so I placed an intense light source that is far outside and to the upper left of the image. This causes the edge of the crater on the left side to cast a strong diagonal shadow over the castle and the head, arms, and lower body of the dragon. These shadows, juxtaposed against the intense light on the dragon's upper torso and wings, create the perfect tonal contrast to draw the viewer directly into the piece.

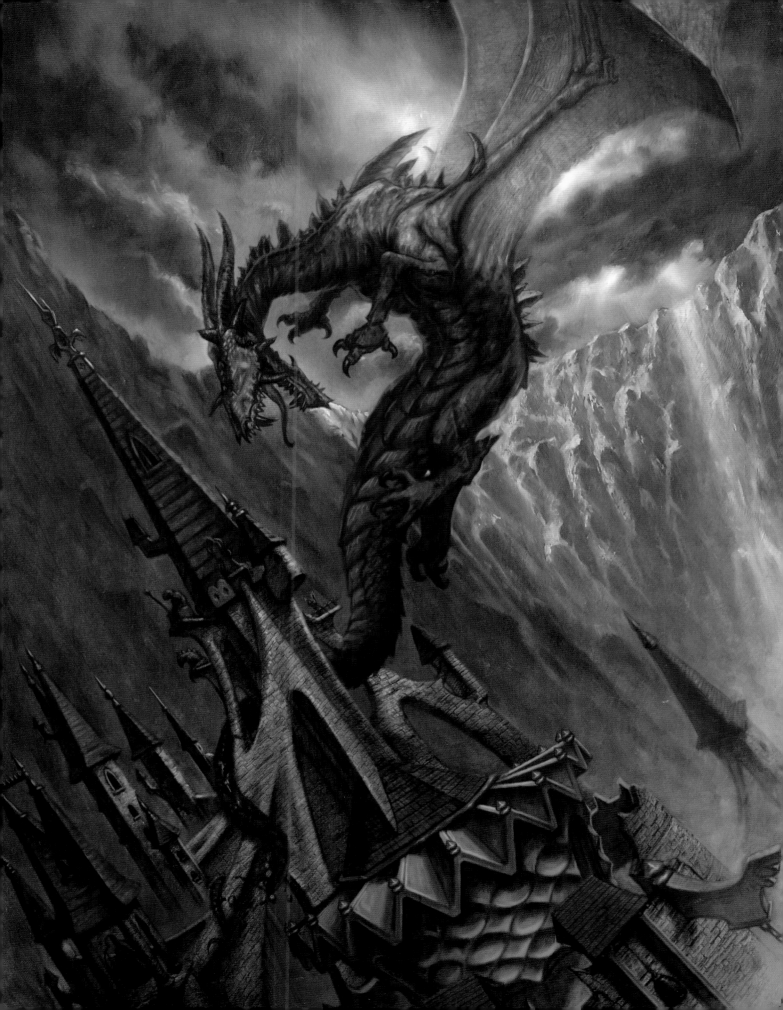

The Harpy

In Greek and Roman mythology, Harpies were cannibal-istic foul-smelling sisters, with the head and upper torso of hideous old hags and the bodies of birds. As a plague set upon the earth by the gods, their presence brought death and decay. Perched on rocky outcroppings, the Harpies anxiously awaited the moment of ambush on seafaring ves-sels and reveled in the subsequent feast on the crew's flesh.

view of a taloned terror

Perching a creature on an outcropping is a clas-sic fantasy pose and will work well for our Harpy. Since she has thin bird legs and a bulky torso to accommodate her wings, a profile view offers the best opportunity for interesting positive and negative shapes in our drawing.

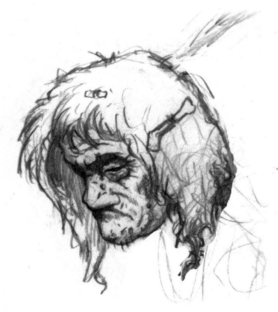

1 Rough in the basic lines for your Harpy, drawing her from a profile view. To capture her gesture, incorporate both the decrepit humanlike elements (e.g., a drooping head and hunched back) and the birdlike aspects (e.g., large wings and small appendages) that make the Harpy a unique creature. Exaggerate the curvature of her spine to balance out her basic shape within a loose diamond.

2 Begin defining the Harpy's face, emphasizing the old hag's tired and ragged appearance. Remember, a large percentage of the success of this drawing relies on creating a face that captures the character of the Harpy. To do this, you must be familiar with what occurs to human skin as it ages. With age, the constant force of gravity and the loss of muscle mass cause the skin to sag. Thus, make the Harpy's skin hang off her cheekbones and lower jaw area by creat-ing a strong shadow under the cheeks and jowls. Suggest droopy eyelids and recessed eye sockets to further illustrate the effects of aging. Add wrinkles radiating outward from the eyelids and mouth and laterally across the forehead. Also, draw in noticeable liver spots and give her unkempt, brittle hair to enhance her sinister look.

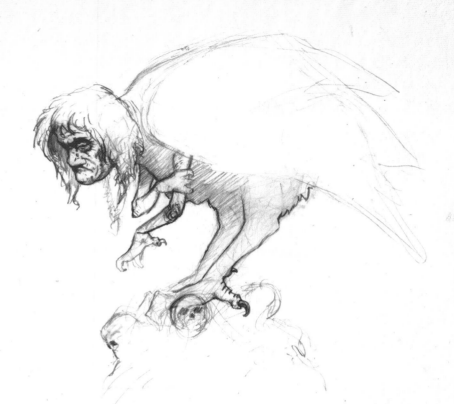

3 Since most of the torso will be covered by giant wings, the limbs of the Harpy are very important in defining her character. Detail the arms using a mix of bird and human anatomy. While keeping the basics of a withered old woman's biceps, triceps, and forearms, give her four talons instead of five fingers, and make the elbow joint more avian by adding deep concentric wrinkles around it. Conversely, make the Harpy's legs completely birdlike. Examine the legs of various birds of prey for inspiration. Leave the remainder of the Harpy's torso in the shadows, creating excellent negative shapes in conjunction with the limbs.

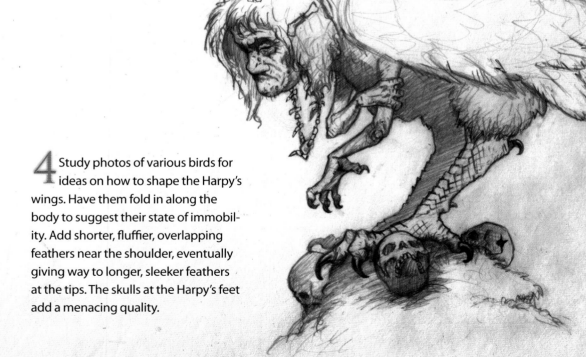

4 Study photos of various birds for ideas on how to shape the Harpy's wings. Have them fold in along the body to suggest their state of immobility. Add shorter, fluffier, overlapping feathers near the shoulder, eventually giving way to longer, sleeker feathers at the tips. The skulls at the Harpy's feet add a menacing quality.

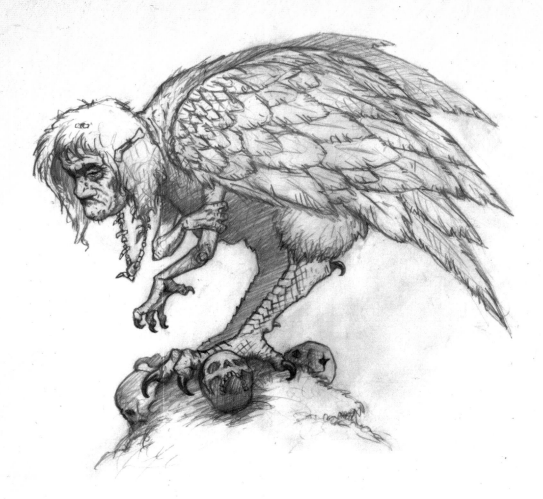

5 Finish off the drawing by completing the wings. Draw shorter, fluffier overlapping feathers near the shoulder. From the neck down they are called nape, scapular, and mantle feathers. These should give way to longer, sleeker feathers as you move toward the wing tip. The feathers farther away from the body are called tertiary, secondary, and primary feathers. As with hair, it is not necessary to draw every detail of every feather. Concentrate on the feathers' shapes and edges, and add small strokes of detail from there.

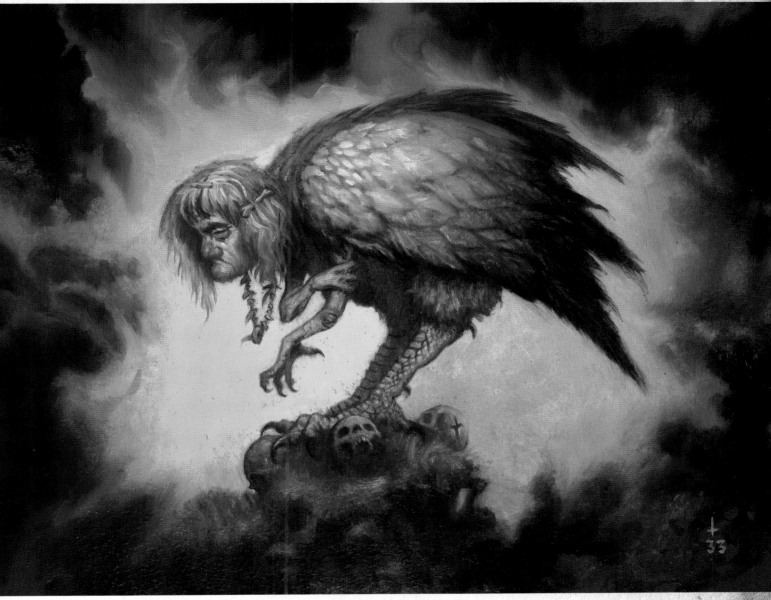

EXAMINING THE FINISHED PRODUCT

Once again, I decided to take a trip around the color wheel, stopping frequently along the way to use basic colors. I find this works well when the central figure is primarily composed of black and white. I set out using a mainly complementary color scheme of yellows and purples for the background. I then mixed in a smattering of other colors, including orange, red, blue, and green. This may seem like too much but using some cool grays to transition between the colors helps pull it together.

The Chimera

Like the Harpy, the legend of the Chimera stems from classical Greek and Roman mythology. Most renditions of the Chimera depict a monster with the body of a goat, the hindquarters of a great reptile (usually a dragon), and the forequarters of a lion. What's more, the classical Chimera has three necks, each topped with the head of an animal that makes up its body.

 ### three heads in one

Let's set tradition aside in favor of trying something different and daring for our Chimera. Instead of having three necks topped with three different animal heads, we will give our beast one large neck crowned by a grotesque combination of the lion, goat, and dragon that make up its body. To make things even more interesting and original, we'll place two other necks on our chimera, but these will remain headless for effect. With this concept established, we can adjust our gesture lines and begin our drawing.

1 Pose your Chimera as though it were rearing up before the viewer with all of the grace and savagery of the king of beasts. Spread its forelimbs wide open in rage and drive its rear limbs forward for the slaughter. Starting with the Chimera's head, have the primary gesture line follow a curvature similar to that of a question mark. Make the secondary gesture lines connecting the limbs, neck, and wings follow intersecting arcs throughout the body.

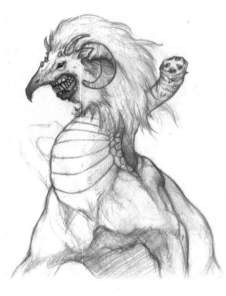

2 Pay special attention to the Chimera's head and neck to capture the design concept we've established (see sidebar). Incorporate the most recognizable aspects of the lion, goat, and dragon so that people can still recognize your creature as a Chimera. In specific, add the mane of a male lion; the horns, chin scruff, and ears of a mountain goat; and the thick, curving neck and long, sharp, pointed snout of a dragon. Make the second and third necks of the Chimera much thinner than the main neck, crafting the tops to look as though previously existing heads have been severed. In my imagination, the Chimera consumed both of its other heads and was transformed into the foul mutation on these pages.

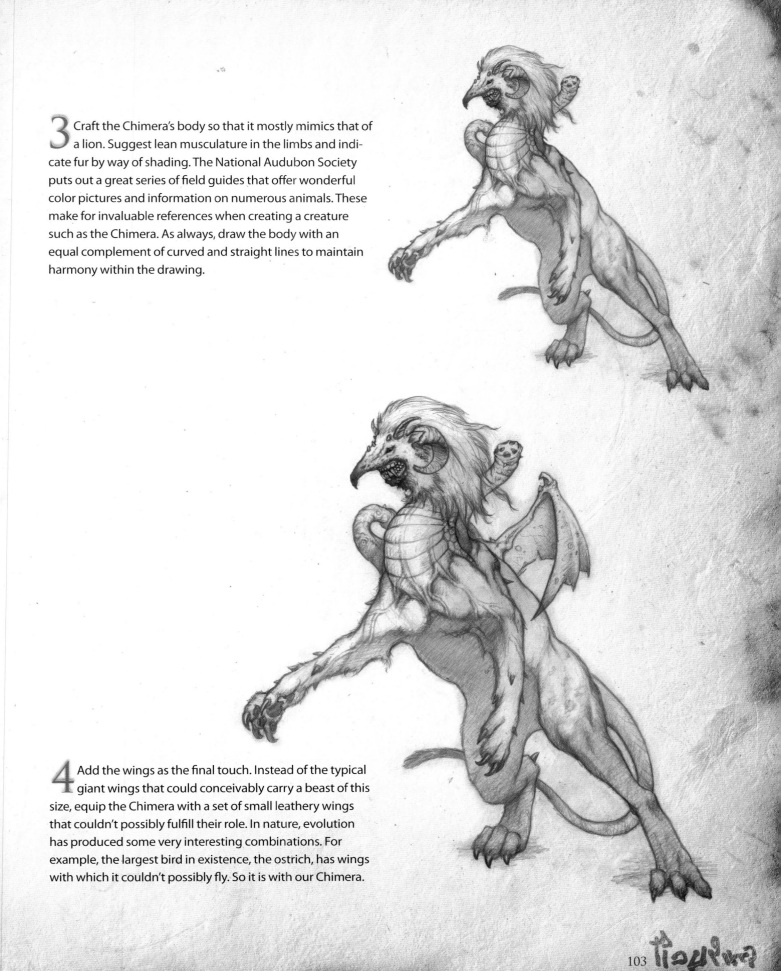

3 Craft the Chimera's body so that it mostly mimics that of a lion. Suggest lean musculature in the limbs and indicate fur by way of shading. The National Audubon Society puts out a great series of field guides that offer wonderful color pictures and information on numerous animals. These make for invaluable references when creating a creature such as the Chimera. As always, draw the body with an equal complement of curved and straight lines to maintain harmony within the drawing.

4 Add the wings as the final touch. Instead of the typical giant wings that could conceivably carry a beast of this size, equip the Chimera with a set of small leathery wings that couldn't possibly fulfill their role. In nature, evolution has produced some very interesting combinations. For example, the largest bird in existence, the ostrich, has wings with which it couldn't possibly fly. So it is with our Chimera.

Koshei the Deathless

Koshei the Deathless is a creature derived from Russian folklore. His name is actually the Russian word for bone, and once you hear the dreaded sound of his wings cutting through the air, it's too late: You're doomed. Koshei cannot be killed because his soul is kept in a hiding place far from his body—a body fed by blood as cold as the Siberian tundra. Koshei can be classified as a demon, the male counterpart of Baba Yaga, the female demon made popular in the Hellboy comic series written and illustrated by the supremely talented Mike Mignola.

aggressive posture

Dramatic and forceful: These are the two words Koshei's pose should invoke. Koshei is absolutely without fear, and his aggressive nature knows no bounds. To capture that kind of force and power, we will make some bold and aggressive moves of our own. In the tradition of the classic comic book pose, we will place the camera high in the air as Koshei flies toward it, his clawed hand extended straight out, ready to snatch out the viewer's eyes.

1 Block in the basic stance of Koshei, the camera placed high above his body to give the spectator a bird's-eye view. To create even more drama within the pose, force the perspective by making the outstretched hand enormous, almost as large as the entirety of his upper torso. As the rest of his body moves away from the camera, make it increasingly smaller. Suggest Koshei's wings, stretching them out at dynamic angles from his body and running them off the edges of the page.

2 Since Koshei's name is derived from the word for bone, incorporate plenty of bone elements into your design. Construct a helmet and some shoulder armor that are made of the skulls and jawbones of creatures that Koshei has slain. Notice the crisscross pattern that has begun to emerge from the rough lines used to draw Koshei's pose. Expand on this throughout the piece. The horns on his helmet, as well as his wings, limbs, and tails, should all follow this same pattern. In keeping with the bone motif, draw a chest plate that resembles ribs and a sternum.

3 Arm Koshei with a weapon that is symbolically associated with Russian folklore, the war hammer. Since Koshei's armor is made up of so many shapes and materials that are organic in nature, a sturdy, hard-edged iron hammer will make for a great eye-catching disparity. Although the hammer should be large, be careful not to make it so large that it visually competes with Koshei's outstretched hand.

4 Render Koshei's batlike wings, filling the main limb structure of the wings with small runes that are reminiscent of Cyrillic writing. Unless you know someone who can translate the Cyrillic alphabet, do not take characters directly from it, as you may wind up writing something goofy or offensive to Russian natives. Scatter similar runes throughout Koshei's body. Put some on his helmet, and add one to the palm of his hand, as if branded. This will give him an air of arcane magic that coincides well with a demon that is devoid of a soul.

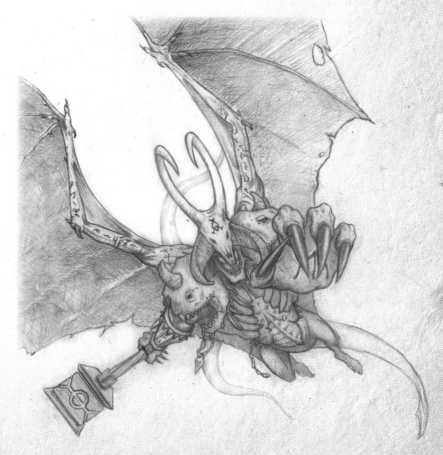

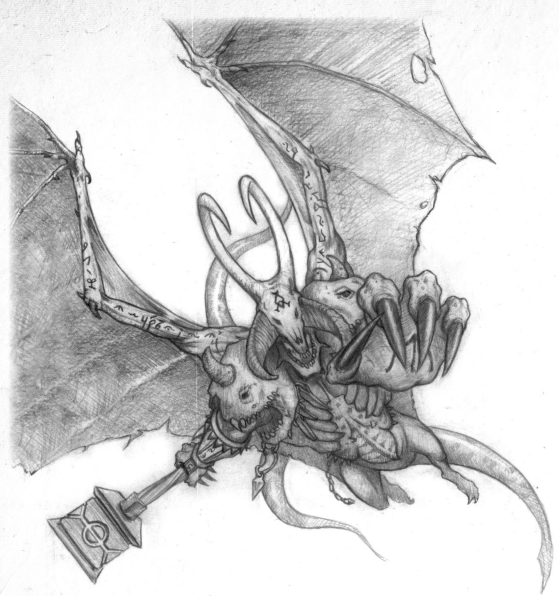

5 Add Koshei's tails, originating them at different points along his back and making them move in a serpentine manner along the crisscross guidelines established earlier. Let your pencil travel lightly across the page as you work your way towards the end of the tails, making it look as though they eventually disappear into the surrounding atmosphere.

EXAMINING THE FINISHED PRODUCT

I painted this piece using the water-based dye method. As the colors began to mingle and pool, the round shape at the bottom of the piece emerged. While researching Koshei, I read that his soul was kept far away on an island, so I decided to run with that concept and turn the simple round shape into that island. I intensified the blues in the rest of the background to suggest water. I made the bone of Koshei's armor black instead of ochre to imbue him with a strong aura of doom, and I chose green for his skin to imply reptilian aspects. To distinguish his eyes from the rest of his head and upper body, I added a yellow light source to the eye and nose openings of his helmet.

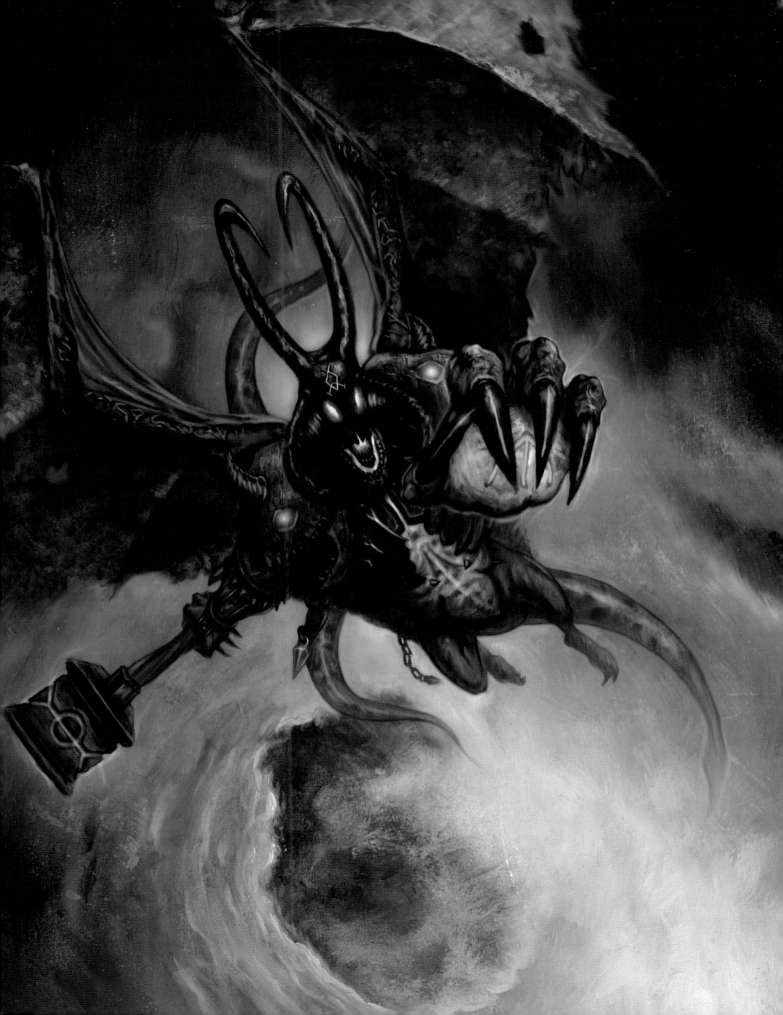

The Ropen

The ropen originates in the legends of New Guinea and is believed to be a direct descendant of the prehistoric pterodactyl. This nocturnal beast subsists on a diet comprised mainly of rotting flesh. The ropen will often swoop down upon fresh graves in order to tear up the earth with its claws, penetrate the casket with its razor-sharp beak, and gorge itself upon the rancid flesh of the newly dead. A female ropen's tail is tipped with a cluster of diamond-shaped eggs that have shells like thick crystals. The eggs will drop from her when the embryo inside has reached maturity. If it does not shatter when it hits the ground, a male ropen can fertilize it. Because its shell is so tough, the egg is at no real risk from hungry predators, but once it hatches, the newly born ropen is on its own. The only time it may see either of its parents is if they happen to be swooping down upon the same fresh grave.

developing artistic flare

There is very little, if any, historical reference of the ropen's appearance. This leaves the majority of the decision making up to you. Creatures like this can be the most challenging to design because of the lack of resources, but they can also be the most rewarding. Be confident in your skills, and challenge your own notions of what the design should look like. If you rough in something that you feel you've seen a million times before, start over. Make the beast your own. In doing so you will begin to develop your own artistic style.

1 Capture the ropen in flight, its basic shape suggesting aerodynamic movement. Place its body within a triangular shape whose base is on a diagonal, implying the concept of motion. Then rough in the ropen with the viewer's eye beneath it, further lending to the idea that the creature is in flight.

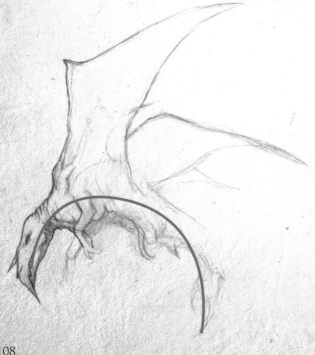

2 With a solid shape and point of view in place, begin concentrating on the design of the monster. Add a large set of leathery wings that serve as the dominant feature of the ropen, inset by a smaller set of insectlike wings. Attach both sets of wings to the body at the same structural point. Construct the ropen's body around a basic curved tubular shape, its pointed head and tail occupying the lowest points on either end of this shape to illustrate gravity and the force of its wings. Shade the underside of the ropen. Even though it flies quite high, it is not higher than the main light source, the moon.

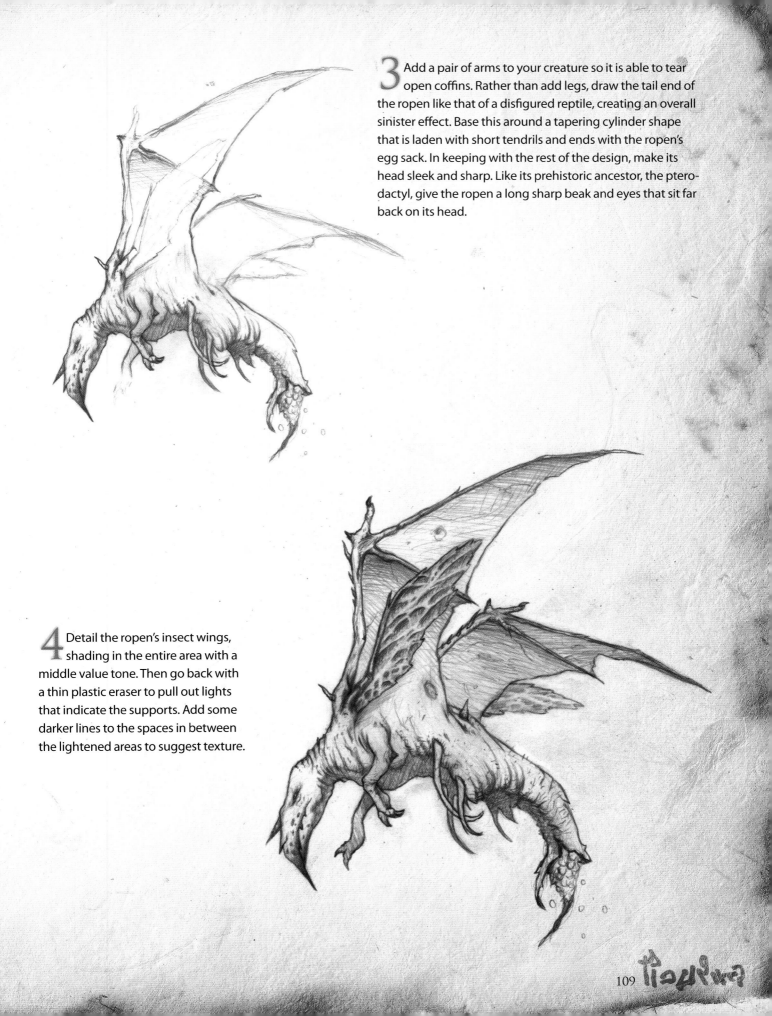

3 Add a pair of arms to your creature so it is able to tear open coffins. Rather than add legs, draw the tail end of the ropen like that of a disfigured reptile, creating an overall sinister effect. Base this around a tapering cylinder shape that is laden with short tendrils and ends with the ropen's egg sack. In keeping with the rest of the design, make its head sleek and sharp. Like its prehistoric ancestor, the ptero-dactyl, give the ropen a long sharp beak and eyes that sit far back on its head.

4 Detail the ropen's insect wings, shading in the entire area with a middle value tone. Then go back with a thin plastic eraser to pull out lights that indicate the supports. Add some darker lines to the spaces in between the lightened areas to suggest texture.

5 Create drama in the drawing by having some of the diamond-shape eggs falling from the tail of the beast. This gives the viewer something to consider other than the design of the ropen, and it adds a bit of story to the image. If a viewer has no knowledge of the history of this beast, the diamond-shape objects falling from its tail may seem more like a defense mechanism. A knowledgeable spectator, however, will recognize the falling diamonds as eggs, inciting his imagination to ponder the possibilities of what will happen to the eggs once they land on the ground. By adding this, you have taken your creature from something cool to look at to an entity capable of reproducing—filling the viewer with wonder.

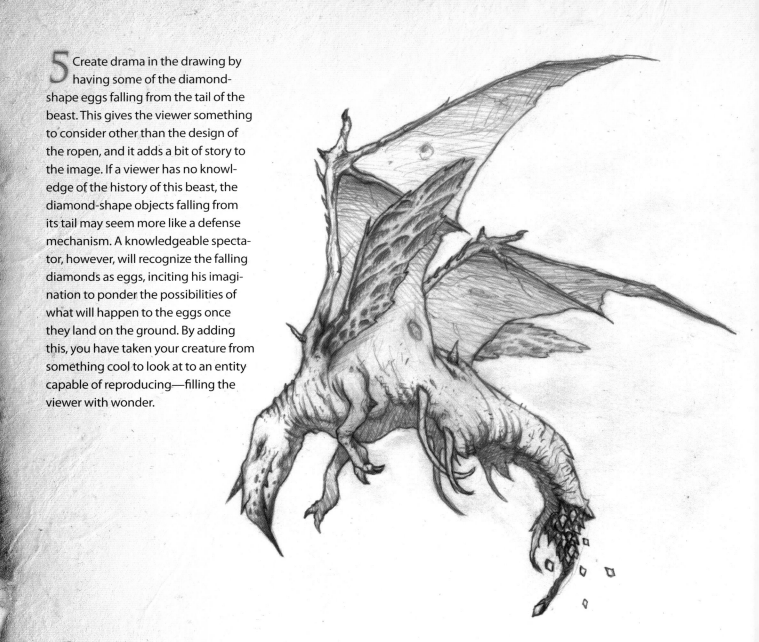

EXAMINING THE FINISHED PRODUCT

I placed multiple light sources throughout this painting to help convincingly place the ropen in its tumultuous primordial setting. I chose a strong red for the sky behind the clouds, creating a reflected light on the underside of the ropen. I painted the large cloud mass behind the ropen's wings using primarily light blues and whites, suggesting a cooler light source. These two light sources combined aid in making the ropen appear three-dimensional.

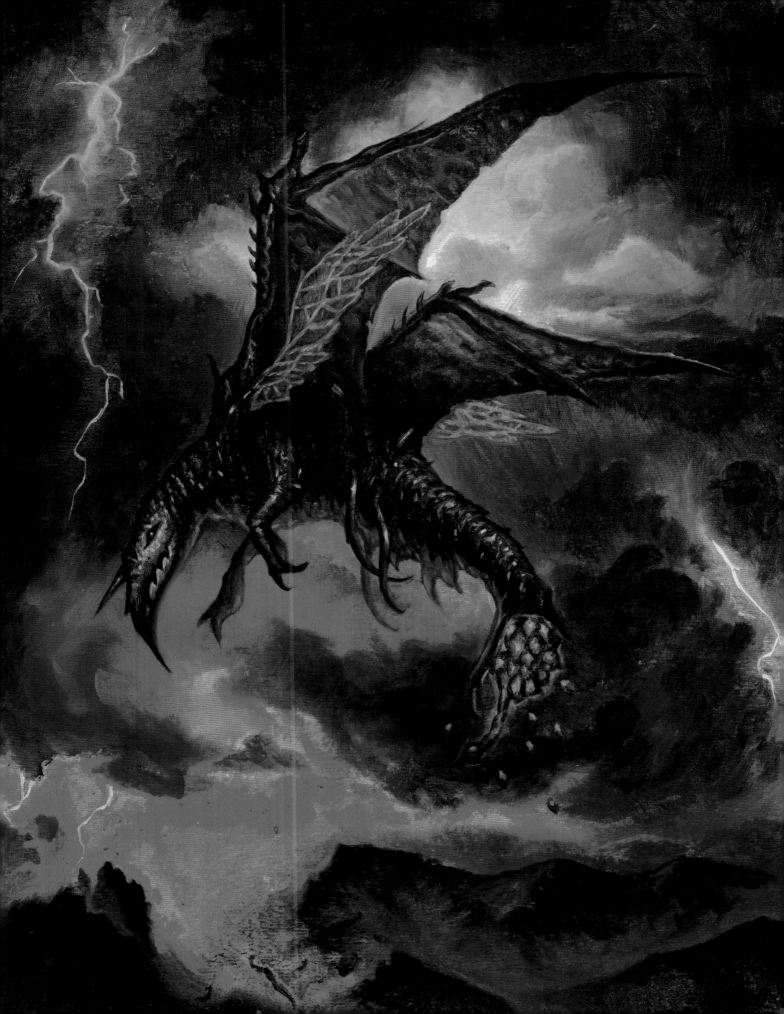

The Demogorgon

Despair, for you have foolishly sought an audience with the Demogorgon. No deals are to be made; no trading of souls or gifts of innocence will persuade this beast from consuming every bit of your essence. It has all been lies up until this moment. The truth you dared not believe has been laid before you, and paralyzed with fear, you now shall die. Your only consolation, small as it may be, is that you will not have to look into the eyes of your tormentor before your excruciating demise, for no one through all of eternity has ever glimpsed the visage of the Demogorgon.

facing the faceless

The greatest challenge in drawing the Demogorgon will be to create the area that its face occupies. Since none have ever looked into the eyes of the great beast, we must devise a creative way to render the face. The simple way out would be to hide it in shadow and treat it as a dark silhouette against a light background. But you're better than that now. We want viewers to look at the overall design of this creature and be disgusted, so a simple shadow isn't enough. A shroud of flayed human flesh would be nice, but that would require eyeholes to see through, so that's out. What if this foul-smelling abomination was constantly surrounded by swarms of flies and other insects? A veil of bugs eternally circling its head is a great solution to our problem!

1 Make the core of the Demogorgon's lower body like that of a giant snake, a multitude of tentacles and other serpentine appendages branching off from its base. Create a sense of movement, making the appendages twist and undulate, running in and out of the picture plane to create a deep space for the monster to occupy. Model the upper half of the beast after a humanoid, giving it a rib cage as well as shoulder and neck structures loosely based on human anatomy. Raise its torso straight into the air and arch its back to give it an air of arrogance befitting a regent of hell.

2 Add the wall of insects that obscures the Demogorgon's face from others yet allows the Demogorgon to spot its next victim.

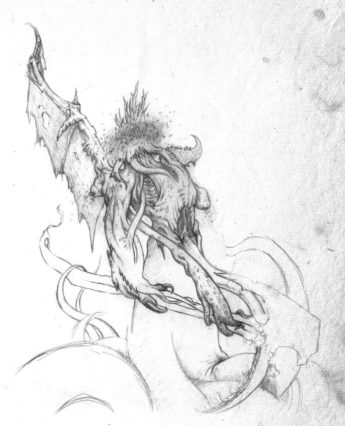

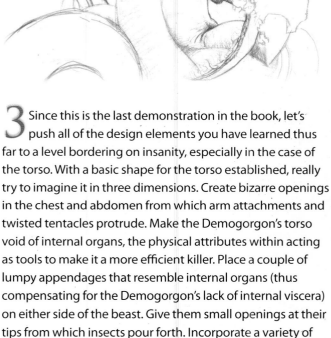

3 Since this is the last demonstration in the book, let's push all of the design elements you have learned thus far to a level bordering on insanity, especially in the case of the torso. With a basic shape for the torso established, really try to imagine it in three dimensions. Create bizarre openings in the chest and abdomen from which arm attachments and twisted tentacles protrude. Make the Demogorgon's torso void of internal organs, the physical attributes within acting as tools to make it a more efficient killer. Place a couple of lumpy appendages that resemble internal organs (thus compensating for the Demogorgon's lack of internal viscera) on either side of the beast. Give them small openings at their tips from which insects pour forth. Incorporate a variety of textures in this area, letting smooth and slimy reptile skin eventually give way to coarse alligator hide.

4 Detail the Demogorgon's single wing, creating wonderful diagonal movement within the piece. Make this wing battered and torn, suggesting that the Demogorgon has a great deal of experience and is aged. Perhaps at one point it had two functioning wings, but after millennia of savage violence, it is left with a single functionless remnant.

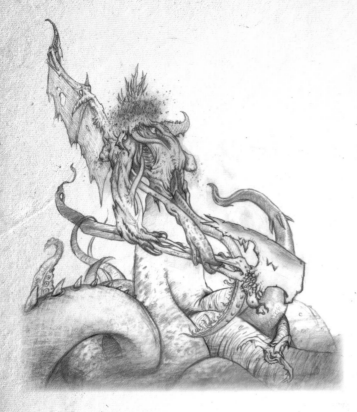

5 Very little about the Demogorgon should be tame. A literal sea of tentacles should support its torso. Make the axe that it wields two-sided with a sharpened stone at one end and something fleshy and animated at the other. Meld teeth, bone, and flesh freely and randomly throughout the design, as the Demogorgon is the epitome of chaos.

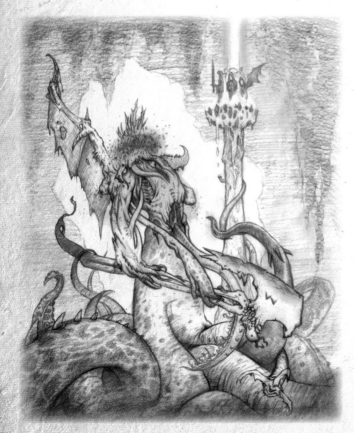

6 Create the Demogorgon's environment: deep underground marked by stalactite formations. Don't worry about rendering every little lump and groove in the stone; simply draw in tonal shapes. Add a large round vessel atop a column of dark stone behind the Demogorgon. Make the vessel reminiscent of a fountain with luminescent ooze pouring into it and dripping over its sides. Place a triad of dark hooded statues in the center of the vessel to give it one last touch of evil.

EXAMINING THE FINISHED PRODUCT

Since the Demogorgon resides in the bowels of the earth, I wanted everything to have a slick, muddy feel to it; thus, I made brown the dominant color throughout the painting. I created an intense, pale light directly behind the creature to make it stand out. To add some color, I painted the ooze coming from the vessel a sickly green color. I let this green work its way to the ground and into some of the tentacles for effect.

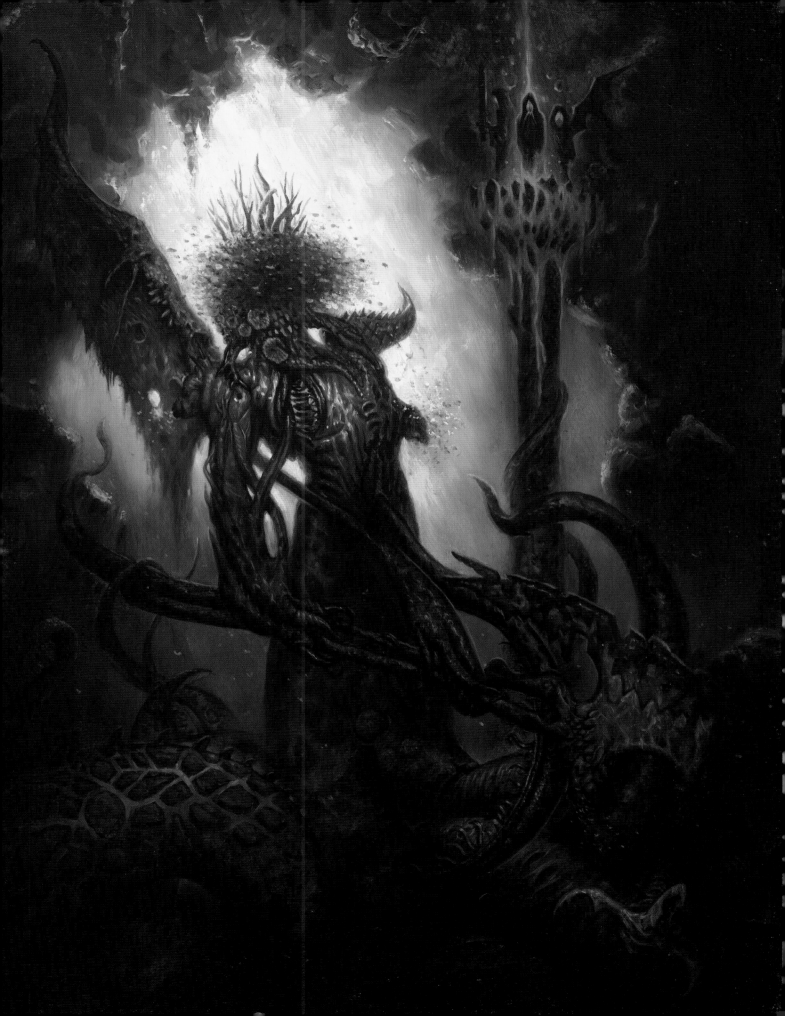

INSPIRATION

People often ask me "Jim, who or what is your inspiration?" Like most artists, I am usually content to rattle off a list of other artists' names and call it a day. But now that I've presented my work as inspiration for you, I feel I need a better answer. After careful thought, I've come to the conclusion that inspiration is more than admiration for another's work; it is the appreciation of something so finely crafted that it encourages you to strive to achieve that level of skill. Inspiration, then, is the motivation to create.

Creation gives one godlike qualities, which is a powerful thing. The relentless drive to give birth to something that resides in one's imagination is an incredibly special talent possessed by artists of all trades. I find nothing more satisfying than defeating a stark piece of white paper, beating on it with my tools and pulling out some unholy monstrosity that is mine to command. This thrill is what pushes me to continue creating.

Sometimes, though, a creation can be so powerful or provocative that it incites fear in others. It threatens what they hold most dear and places them outside of their comfort zones. Don't allow these individuals to stifle your artistic drive: Abandon your fears and create. Don't fear failure. Don't fear what others will think of you. Don't even fear the reprisals of the gods you have angered with your work. Embrace the creative instincts within, and hone and hammer them until they are razor sharp. Then, perhaps, your work will become an inspiration to others.

The following pieces are from a personal project entitled "The Geomonticus." I feel these images are the perfect conclusion to the book, as they show you where the principles outlined in the demonstrations can take you. I've also included an appendix of anatomy references so you'll be able to give your drawings the lifelike qualities you desire. I hope these images will inspire the artist within you, and motivate you to create.

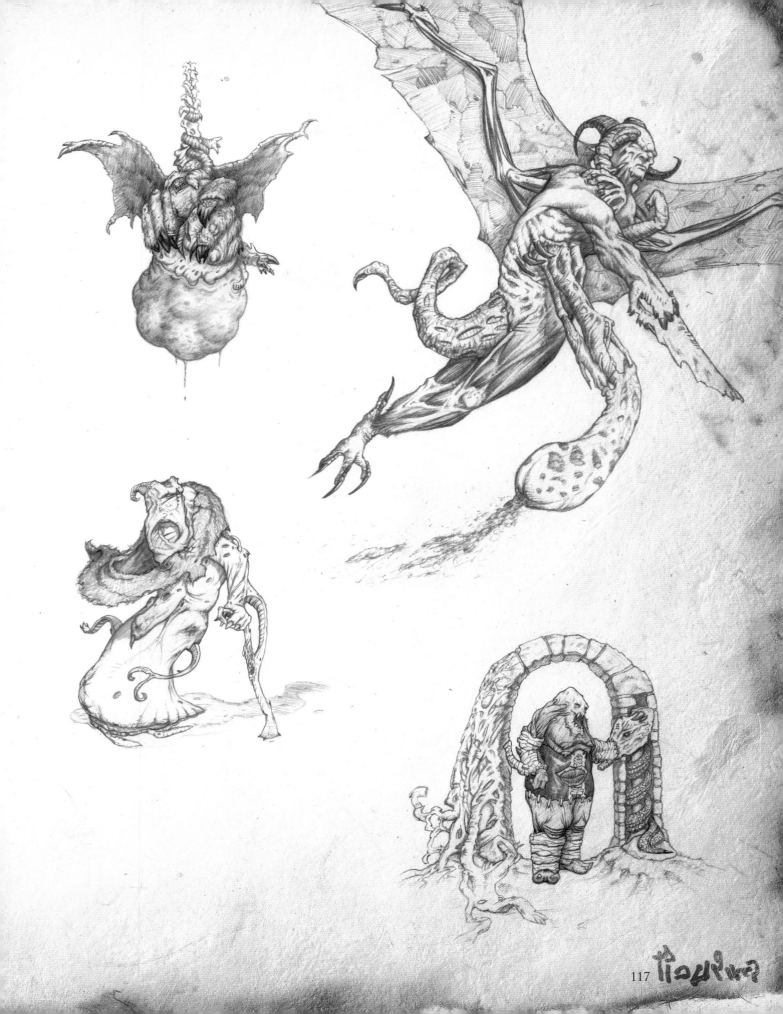

117

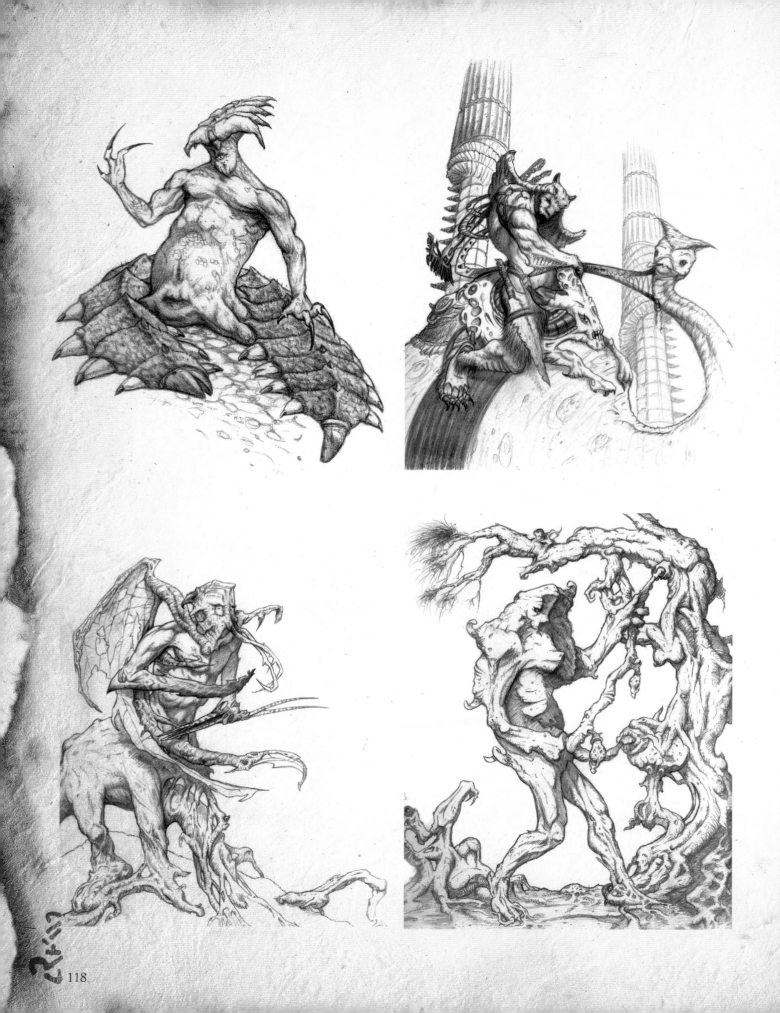

Human Skulls

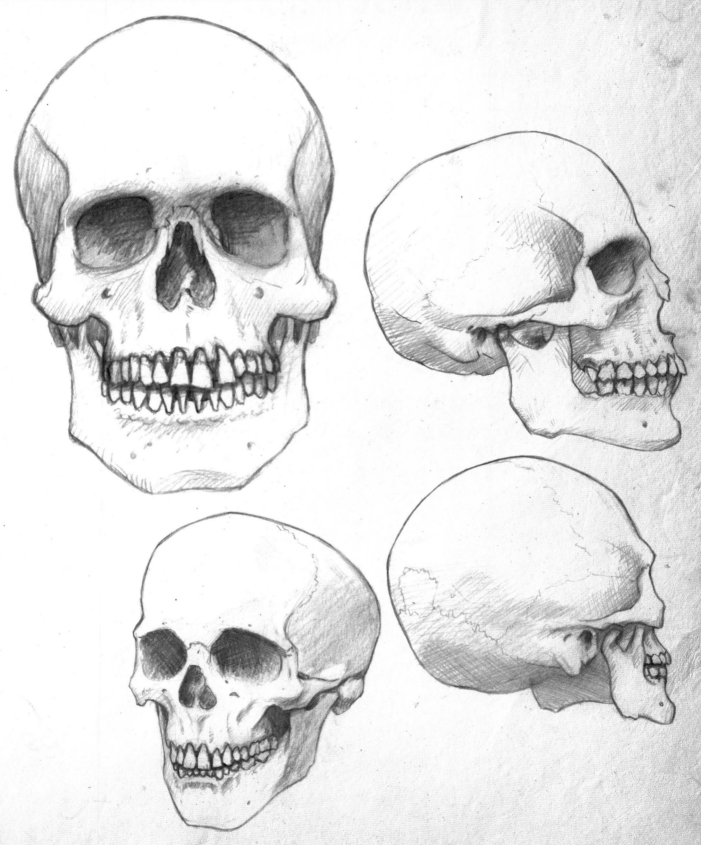

Animal Skulls

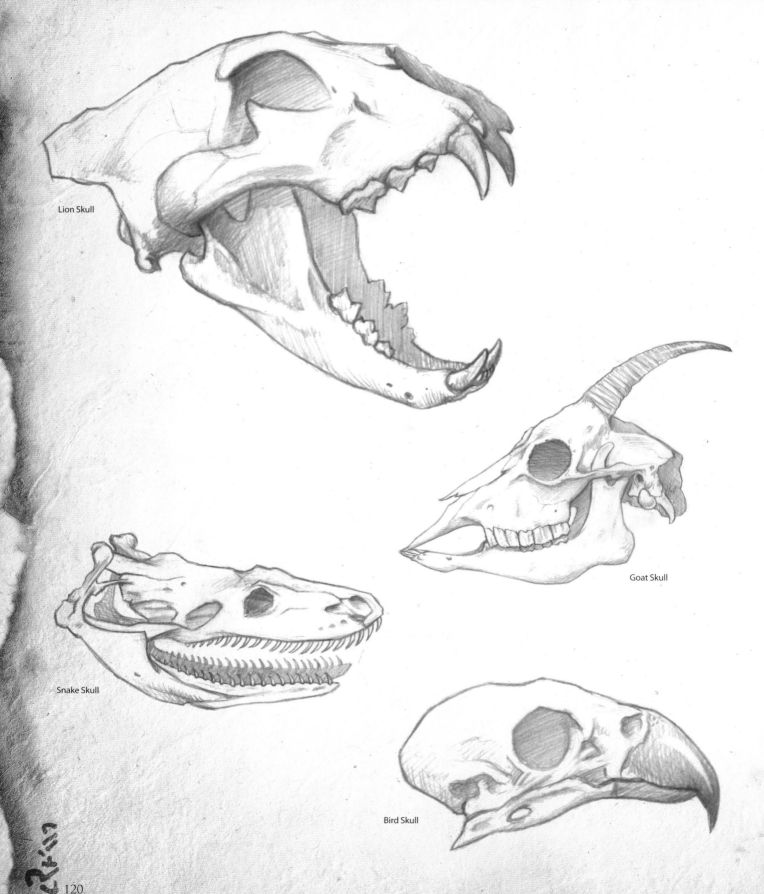

Lion Skull

Goat Skull

Snake Skull

Bird Skull

HORNS, HOOVES, AND CLAWS

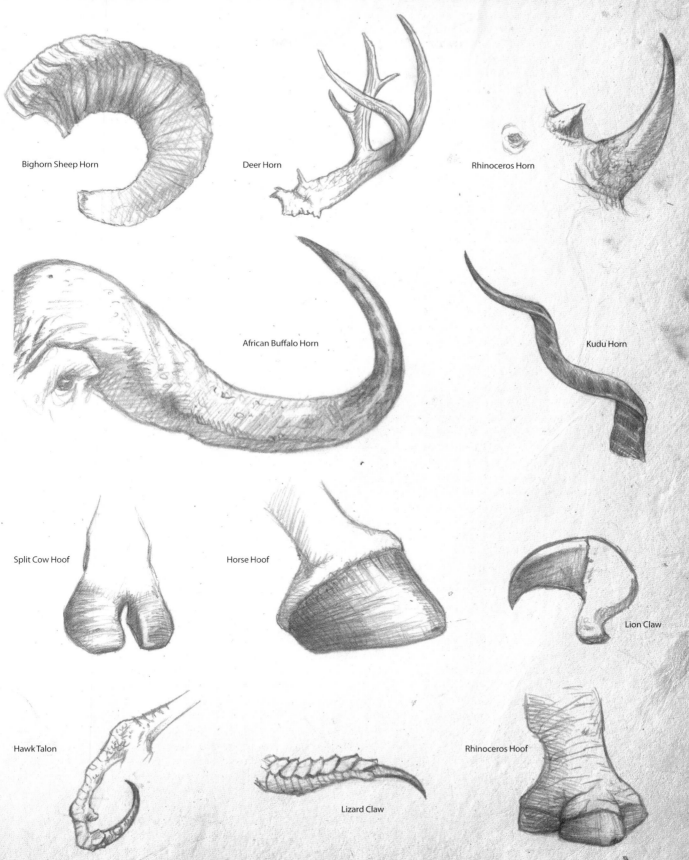

Bighorn Sheep Horn

Deer Horn

Rhinoceros Horn

African Buffalo Horn

Kudu Horn

Split Cow Hoof

Horse Hoof

Lion Claw

Hawk Talon

Lizard Claw

Rhinoceros Hoof

Human Anatomy

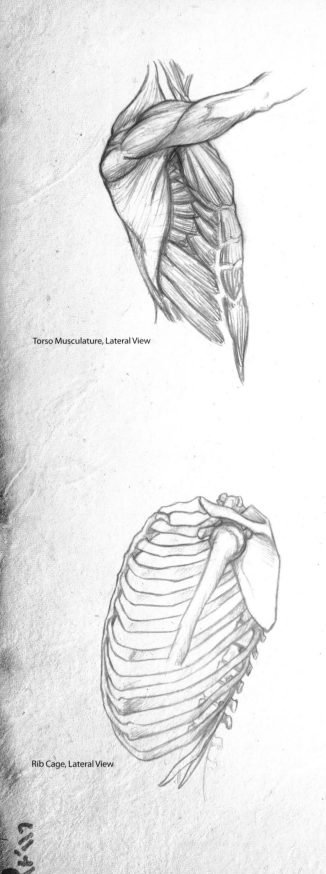

Torso Musculature, Lateral View

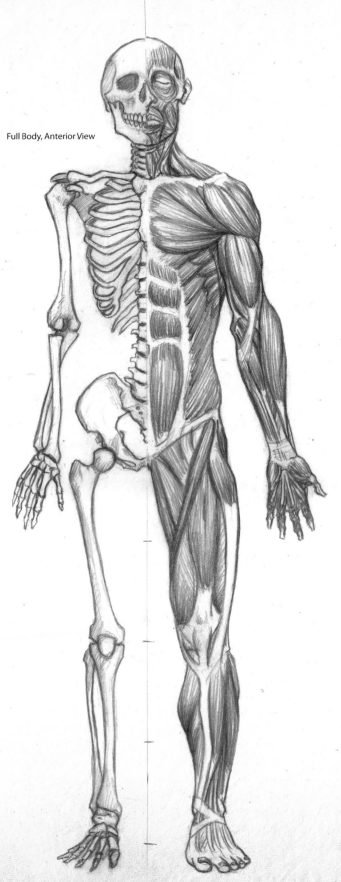

Full Body, Anterior View

Rib Cage, Lateral View

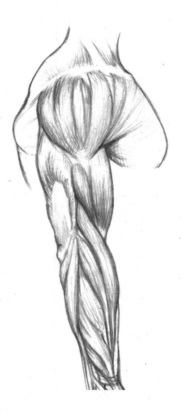

Arm Musculature,
Lateral View

Leg Musculature,
Medial View

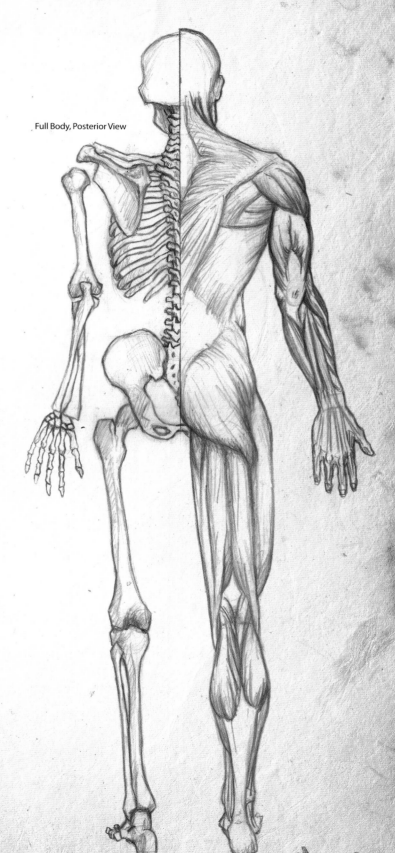

Full Body, Posterior View

123

Animal Anatomy

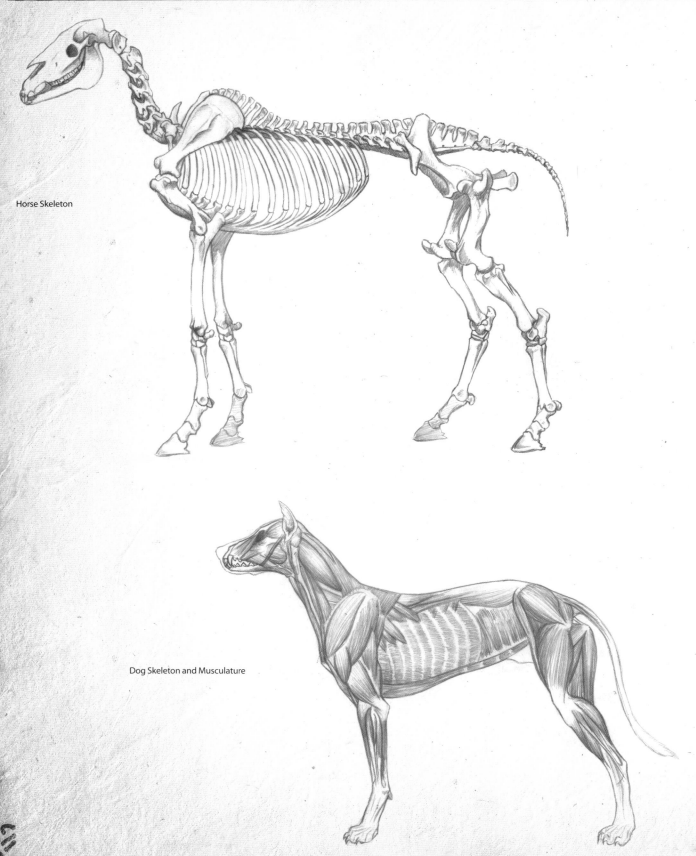

Horse Skeleton

Dog Skeleton and Musculature

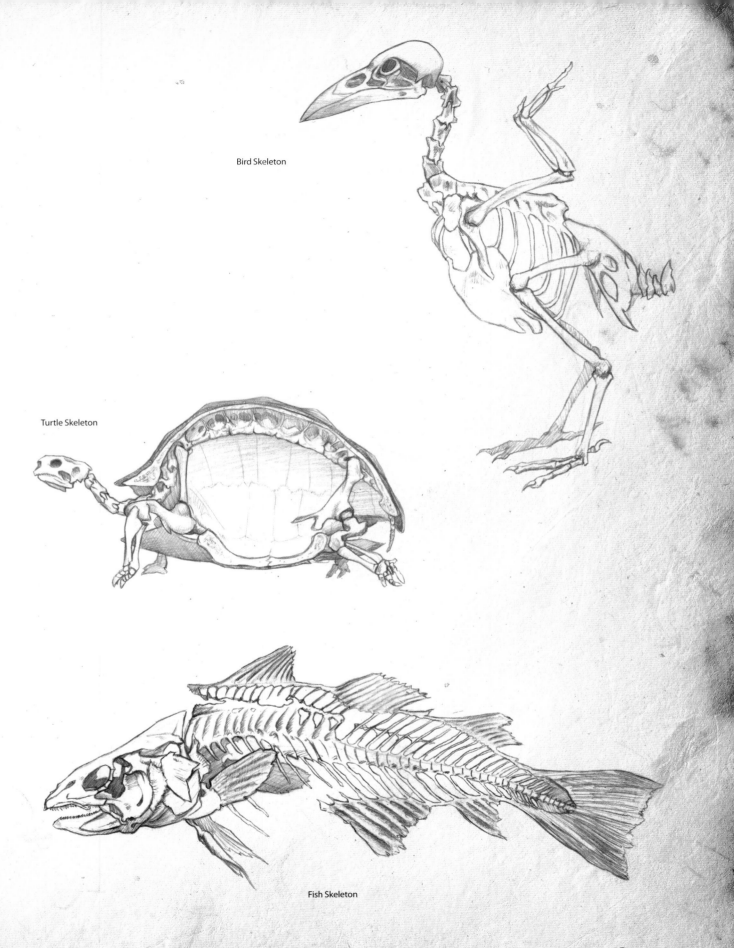

Bird Skeleton

Turtle Skeleton

Fish Skeleton

125

INDEX

IF YOU'RE GOING TO DRAW—
DRAW WITH IMPACT

ISBN-13 978-1-58180-657-1
ISBN-10 1-58180-657-4
paperback, 128 pages, #33252
Nothing makes the imagination catch fire like the dragon, one of the most enduringly popular beasts of legend. Now you can learn simple secrets and tricks for creating your own dragon artworks. Let your imagination soar as you bring majestic dragons and other mythical creatures to life using J. "NeonDragon" Peffer's easy-to-follow progressive line art demonstrations.

ISBN-13: 978-1-58180-682-3
ISBN-10: 1-58180-682-5
paperback, 128 pages, #33271
Discover how to sketch, draw and color your own fantasy worlds with *Fantastic Realms!* This instructive guide gives you over forty lessons for creating characters, creatures and settings. Complete with an appendix to help you invent your own characters and scene characteristics, you'll soon be on your way to bringing your fantasy world to life.

ISBN-13: 978-1-58180-907-7
ISBN-10: 1-58180-907-7
paperback, 128 pages, #Z0543
Discover how to draw and paint the amazing, dynamic array of characters, creatures and landscapes with this absorbing and practical guide. You'll learn to draw and paint fantasy subjects and render realistic details such as expression and movement. You'll also find stunning finished illustrations by top fantasy artists such as Bob Hobbs and Anthony S. Waters enabling you to see the process from sketches to amazing finished works!

ISBN-13: 978-1-58180-606-9
ISBN-10: 1-58180-606-X
paperback, 128 pages, #33164
You'll love drawing the monsters lurking in *Manga Monster Madness*. Put pencil to paper with 50 easy-to-follow lessons for drawing everything from aliens and mutants to the supernatural.

THESE BOOKS AND OTHER
IMPACT TITLES ARE AVAILABLE
AT YOUR LOCAL BOOKSTORE OR
FROM ONLINE SUPPLIERS.